The Art of Silliness

A Creativity Book for Everyone

Carla Sonheim

A Perigee Book

A PERIGEE BOOK
Published by the Penguin Group
Penguin Group (USA) Inc.
375 Hudson Street, New York, New York 10014, USA

Penguin Group (Canada), 90 Eglinton Avenue East, Suite 700, Toronto, Ontario M4P 2Y3, Canada (a division of
Pearson Penguin Canada Inc.) • Penguin Books Ltd., 80 Strand, London WC2R 0RL, England • Penguin Group
Ireland, 25 St. Stephen's Green, Dublin 2, Ireland (a division of Penguin Books Ltd.) • Penguin Group (Australia),
250 Camberwell Road, Camberwell, Victoria 3124, Australia (a division of Pearson Australia Group Pty. Ltd.) • Pen-
guin Books India Pvt. Ltd., 11 Community Centre, Panchsheel Park, New Delhi—110 017, India • Penguin Group (NZ),
67 Apollo Drive, Rosedale, Auckland 0632, New Zealand (a division of Pearson New Zealand Ltd.) • Penguin Books
(South Africa) (Pty.) Ltd., 24 Sturdee Avenue, Rosebank, Johannesburg 2196, South Africa
Penguin Books Ltd., Registered Offices: 80 Strand, London WC2R 0RL, England

While the author has made every effort to provide accurate telephone numbers, Internet addresses, and other contact
information at the time of publication, neither the publisher nor the author assumes any responsibility for errors, or for
changes that occur after publication. Further, the publisher does not have any control over and does not assume any
responsibility for author or third-party websites or their content.

THE ART OF SILLINESS
Copyright © 2012 by Carla Sonheim

PERIGEE is a registered trademark of Penguin Group (USA) Inc.
The "P" design is a trademark belonging to Penguin Group (USA) Inc.

First edition: November 2012
ISBN: 978-0-399-53758-5
PRINTED IN THE UNITED STATES OF AMERICA
10 9 8 7 6 5 4 3 2

Most Perigee books are available at special quantity discounts for bulk purchases for sales promotions, premiums,
fund-raising, or educational use. Special books, or book excerpts, can also be created to fit specific needs. For de-
tails, write: Special Markets, Penguin Group (USA) Inc., 375 Hudson Street, New York, New York 10014.

For my boys

The Art of Silliness: *An Introduction*

I am not really a very silly person.

I'm actually a pretty serious person — I take things to heart, as a rule. My art, especially. It's important to me to be "good," the best I can be at any given time.

But "serious" does not equal "solemn," and I feel lucky that I learned somewhat early on that keeping things fun is the only way to go.

When I started drawing again at age 30, I drew only on the days I truly enjoyed it. On

days it was frustrating, I didn't draw. But on the days I enjoyed it, I drew a lot. Keeping drawing fun kept me *drawing*.

Some years later during lunch with friends, I was asked to show them how to draw. I gave them an exercise that I must have found in a book at some point. Almost everyone was enjoying themselves, but I noticed my friend Wendy struggling. She would put pen to paper, hesitate, then pull back. She tried once more, but in the end, couldn't do it.

Having come to drawing later in life myself, I could relate; drawing IS scary, especially if you've been told early on (directly or indirectly), that unless you had "talent" you shouldn't bother. Sadly, many of us stopped drawing as children for this very reason.

About the same time, my youngest son entered first grade, and I was asked to teach art to his class on a regular basis. This became an almost full-time position by the time Wes finished grade school, and I learned pretty quickly that in order to keep 25 kids from melting into chaos, I had to make it fun — even *silly*.

Because kids are the original Silly People. They delight in the smallest things, and aren't embarrassed about it either! Absurdity is king. So I tried to incorporate some of that spirit into my lessons: We did Picasso-inspired pet portraits, Christo-inspired wrapped toys, and Michelangelo-inspired charcoal drawings of the Sistine Chapel (created while taped under their desks); fun for them and fun for me, too!

But that didn't mean the lessons weren't "serious" as well. My son Wes was the kind of kid that wanted the straight truth, with no dumbing down. So when I taught drawing to him and his classmates, I simply turned regular "adult" exercises on their heads. We did blind contours of giraffes, contour drawings of stuffed animals, wrong-handed portraits of the teacher...the kids could handle these classic exercises—and loved them.

When I started teaching adult students a few years later, on a whim (and remembering my friend Wendy) I tried teaching with the same silly exercises, games, and techniques. And it worked! Adult students began telling me how much this approach had helped them minimize the "fear factor" of drawing, and these exercises were the beginnings of my first book, *Drawing Lab for Mixed Media Artists: 52 Creative Exercises to Make Drawing Fun.*

But then I got to thinking...why not take it a step further? What if I presented the material in

a way that was even less threatening than words on a page? Something intimately familiar to the kid in us...*Worksheets!*

When I was a young girl, "worksheets" equaled "fun." They had all these little "assignments" that I could do in manageable chunks. Throw in there a puzzle or two, and a learning session was complete.

A blank sheet of paper can be a scary thing. A worksheet, however, where you just follow directions and fill in a little box, is "easy."

So in 2010 I created an online class called "The Art of Silliness: Drawing Worksheets for Adults," and the response was quite overwhelming. One student wrote:

I have been anxious for years about putting pencil to paper in the fear of drawing something silly, and here was a class positively encouraging me to do just that. After the initial wariness and a few "this is just silly," I loved it! It really opened a door for me which I have been wanting to walk through for ages. All the different little exercises work on so many levels. I didn't even realize this at the time as I was too busy feeling the creative enjoyment I felt when I was a little child and no one criticized my work, least of all me.

So here we are. A serious person bringing you The Art of Silliness, creative prompts and traditional drawing exercises presented in a "silly" way, hoping to help break through some of the barriers that might have stopped you from drawing until now.

Or...perhaps you can draw well, but have lost some of the joy you used to feel when younger and new to drawing. *The Art of Silliness* can help put the fun back into drawing!

Or...maybe you want to learn to draw alongside your children or grandchildren, and think this might be a fun way to do it.

Or...you just want to try to tap into the child in you, the one who used to delight in all things silly and creative.

Whatever the case, I'm so glad you're here.

Carla Sonheim

P.S. During the original online course, "Fleep" emerged as the nonsense language of Fleepland (aka "Sillyland"), and the Silly Queen ("Squeen") made her appearance as well. You'll see references to this nonsense here in these pages — silly! — as just one more tool to help bring out the child in you and make it fun.

How to Start: *Approach the exercises is this book however you like. Flip through the pages and pick one at random, or start at the beginning; do just one exercise a day, or two or three! Whatever works for you, there is no right or wrong. As always (in drawing and in life), you need to find the way that works best for you.*

When you're ready to start, pick up a...

or a

or a

...and just begin.

(It's really that easy!)

Glossary of Terms

Read through the following drawing-related words or phrases before you start so that you have a feel for the exercises awaiting you.

Blind Contours. A classic drawing exercise designed to get your hands and eyes to work together. You draw the edges or contour lines of your subject without looking at the paper. Results are weird and wonky.

Blobs. A non-technical term describing blotches of paint, lines, or shapes that you can look at and turn into something else, such as a face or an animal.

Cheater Blinds. A hybrid of contour and blind contour drawings (meaning, you can "cheat" by glancing at your paper once or twice).

Composition. The way the elements of a drawing fall on the page.

Contours. A contour is the line that defines the form or edge of a subject. This classic drawing exercise is the same as blind contours, only you are allowed to look at your paper while drawing.

Cross-Hatching. Adding shading to a drawing with the use of little lines that overlap and cross each other. Darker areas are filled in more densely; lighter areas more sparsely.

Design. *Design* and *composition* are often used interchangeably, and refer to how elements in a drawing fall on the page and work together.

Doodles. Here, *doodles* are drawings done while your mind is occupied elsewhere, such as when you are in a meeting or listening to a podcast. The marks you make naturally flow out of you and, like handwriting, everyone's "doodle language" is unique.

"Exquisite Corpse." Refers to a drawing game invented by Surrealist artists in the early 20th century, where each collaborator adds to a drawing in sequence, often by only seeing part of the previous person's drawing. When viewed as a whole, the result is strange and unexpected.

Negative Space. The areas between and around a subject. For example, the space inside the letter O.

One-Line Drawings. Also referred to as **One-Liners,** these drawings are made in one continuous, flowing, and loopy line and are inspired by the one-liners of Pablo Picasso, Paul Klee, Alexander Calder, and others.

"Play with the Lines." A term used in this book when you are asked to thicken and thin lines to add interest and flair to a line drawing.

Shading. Any marks made to show lighter and darker areas of a drawing.

Scribbly Drawings. Drawings made in a scribbling manner, like you were two years old...a quick, scribbly mark describing the essence of something. No details!

Thumbnail Sketches. Small quick drawings, usually in a box, done to work out composition ideas.

White Space. Blank or "white" areas of a drawing, which can also be an effective design component. Sometimes used interchangeably with *Negative Space.*

Wrong-Handed Drawings. Drawings done with your non-dominant hand.

And, until you get the hang of the Fleepiness, here are a few

"Fleep" Terms

Fleep. The official language of "Fleepland." Made up of nonsense words that you, as a Silly Person, invent on a whim.

Fleepland. The homeland of the Squeen (also known as "Sillyland," "Fleepdom" or "The Land of Fleep").

Silly People. Subjects of the Squeen; people of Fleepland; you and me.

Sking. "Fleep" for "Silly King," the father of the *Squeen.*

Squeen. "Fleep" for "Silly Queen" (Silly = "S" + Queen = "Squeen").

Have fun!

Draw This Bird

(Your zillion here.)

A Zillion Times

... or for about five continuous minutes, whichever comes first. But, you have to do it one of these three ways:

1. With your non-dominant hand,
2. With your eyes closed,
3. Or both!

Don't birds EAT ants?

(And here.)

Now look closely at the birds you have drawn. See how they are the same, but different? Even though they all look alike, they each have their own unique personalities. (Drawings are just like people; some you will like more than others. That's okay!)

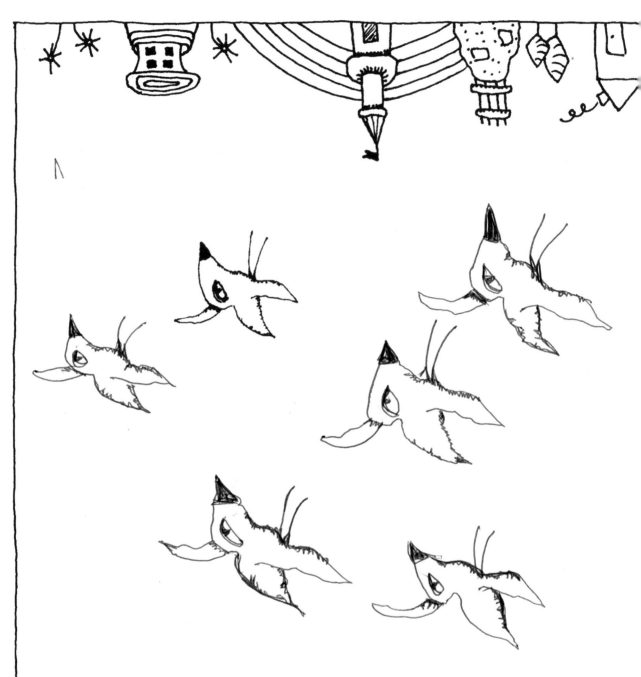

Draw Upside-Down

Draw this Upside-Down Flying Bird three to seven more times with a black marker or a ballpoint pen. (No, you can't erase. Yes, you have to draw them upside-down.) Try not to think "bird." Just concentrate on copying the way the lines curve and connect together.

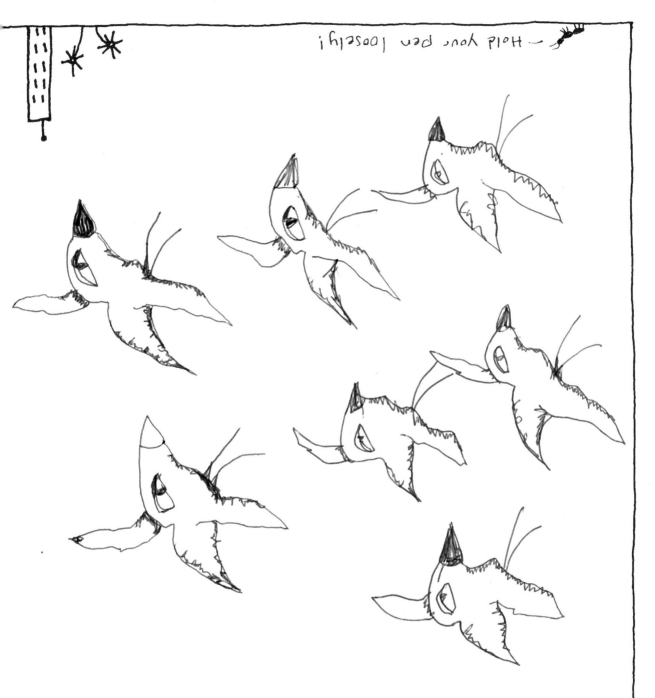

For now, just do your best... really LOOK at the bird shape as you draw, keep your hand loose, and remember to BREATHE. Look at the reference MORE OFTEN than you look at your paper. Use a marker so you are not tempted to erase. Tomorrow you can worry about your results. Today, just draw (and breathe!).

Blind Contour Chairs

Draw three to ten chairs WITHOUT looking at your page.

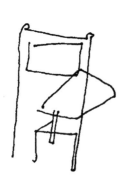

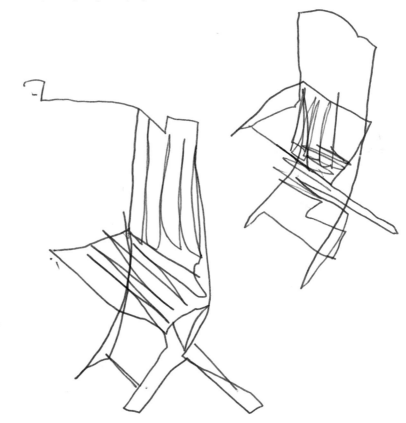

Chairs are hard to draw!
To make it easier, you'll
draw them WITHOUT
LOOKING AT YOUR PAPER.
You will look at the chairs
100% of the time.

Will the drawings look like
chairs?

Sort of...but it doesn't matter!
Blind contours are just an
exercise to get your eyes and
hands to start working together.

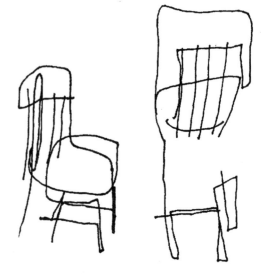

Here's How To Do It: With pen in hand (and a chair in sight), pick an edge and slowly start moving your pen. Try to match the speed of your hand to the speed of your eyes running along the edge of the chair. Draw extra slowly. Go ahead and add inside details, lifting your pen (or not lifting it), as desired. (But don't look!)

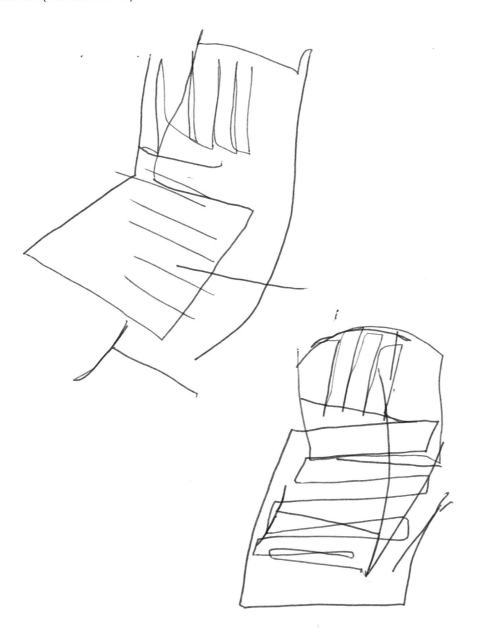

Remember, it's okay if they turn out funny!

Okay. I trust you.

One-Liner Flowers

This assignment is to draw four to eight vases of flowers from your imagination.
The trick: you must do them using ONE line only. In other words, once you put pen to paper, do not lift your pen until your drawing is complete.

Here are a few one-liner tips:

• The drawing should be done fairly quickly, in one flowy motion.

• If you get stuck in the middle of a drawing, try your best not to stop, but just continue drawing it out, even if it ends up a less-than-perfect drawing.

• It helps to talk to yourself while drawing and name some of the parts: "petals," "leaves," etc.

• Please don't "cheat" by getting from one place to another by going over an existing line.

• It should LOOK like one line; your 3-year-old niece should be able to follow the line from start to finish with her finger.

• This will definitely feel awkward at first, but should get easier the more you do it.

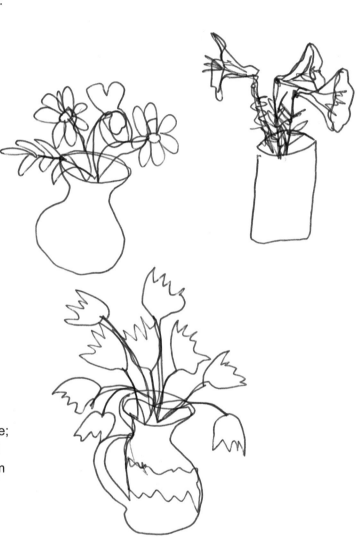

- Think loops!

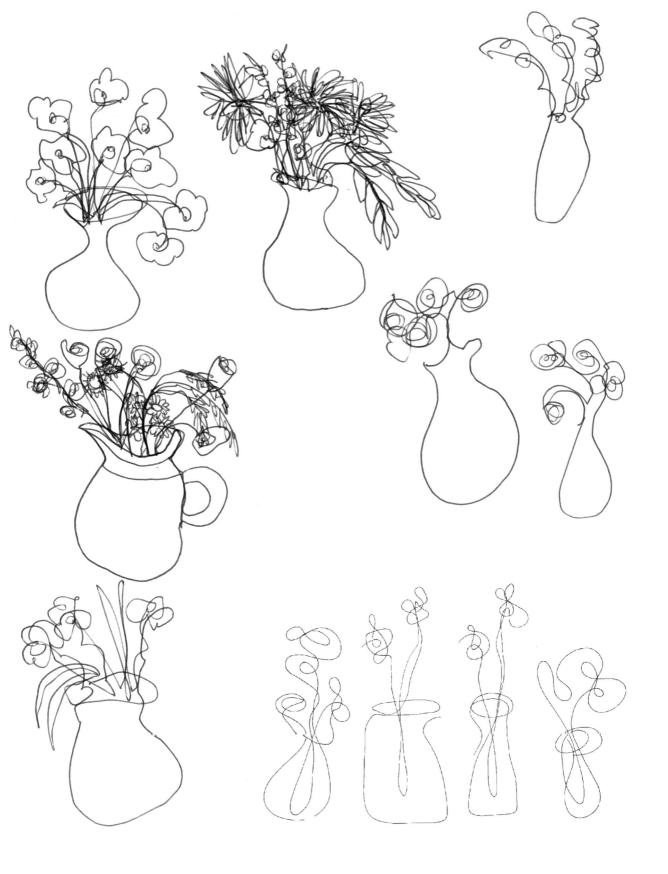

Take Notes

This assignment is to put a pen in your pocket and take "notes" when out and about. You don't need anything fancy; just a pen and a torn piece of paper will do. The notes can consist of thoughts you have, conversations you overhear, sketches, etc.

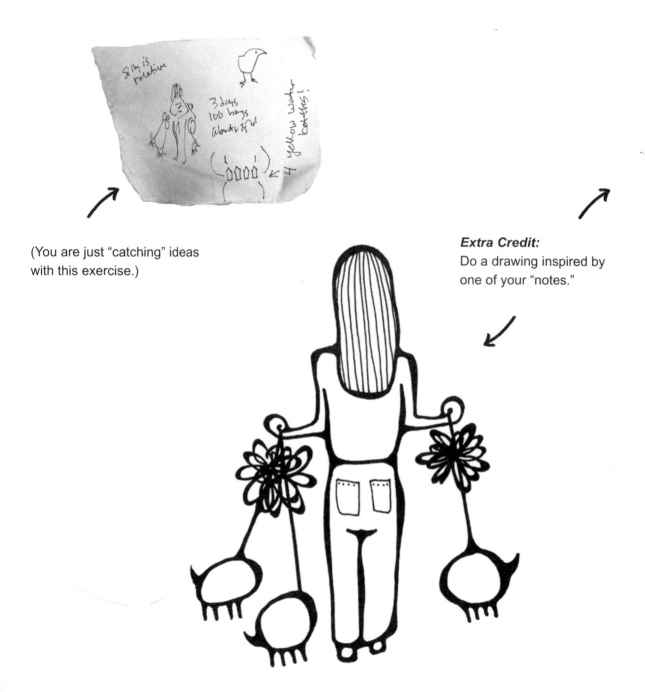

(You are just "catching" ideas with this exercise.)

Extra Credit:
Do a drawing inspired by one of your "notes."

Tear off and put in your pocket!

It's raing while the sun's out. That always feels wrong to me,

Your Extra Credit drawing here.

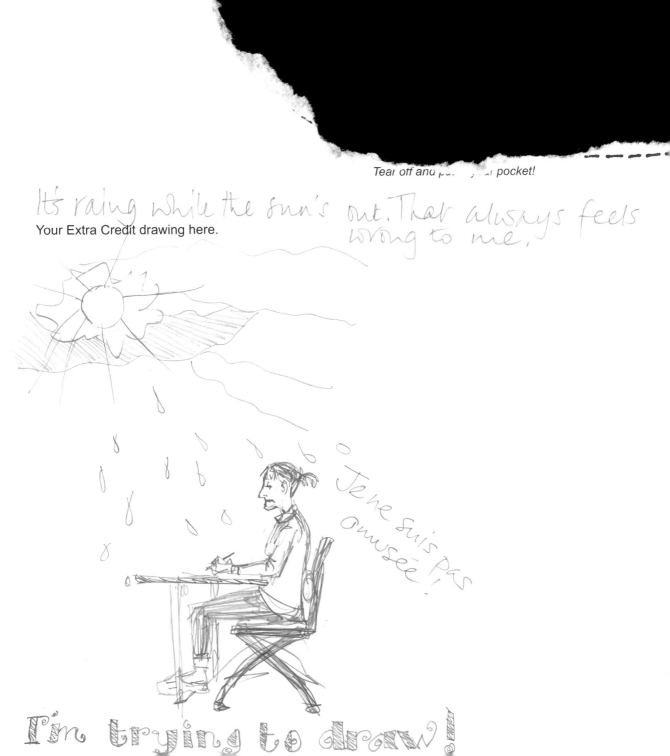

Je ne suis pas amusée!

I'm trying to draw!

Branch Out

Take this book outside and find a branch for this little owl to sit on, then draw it. You may use pencil or pen (but if you use a pencil, don't spend too much — or any — time erasing). You should look at your "branch" MORE OFTEN than you look at your paper. Keep your hand very loose and "sketchy."

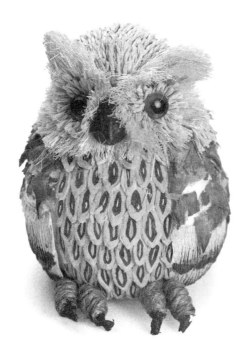

Again, don't worry too much about whether your branch is accurately drawn; just spend your energy looking at your subject and recording what you see.

Turtle Power

Draw two "stacks" of turtles in the columns below using your permanent marker (no erasing!). Do the left column first using your "wrong" hand. Now switch to your "right" hand and draw more turtles in the column on the right.

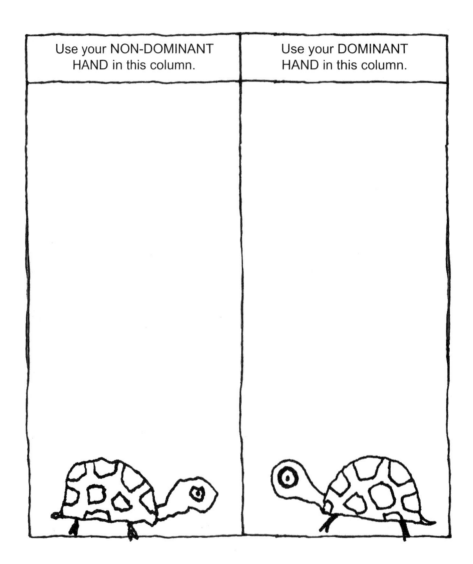

Use your NON-DOMINANT HAND in this column.	Use your DOMINANT HAND in this column.

Now look closely at your two stacks. Which set of turtles do you like better? Often people find they prefer the stack done with the non-dominant hand. Why?

"Draw" with Your Eyes

Lucky pups... this drawing assignment doesn't involve any drawing! Your challenge is to draw the things around you — trees, cars, flowers, dishes, toys, faces — with your eyes ONLY. No pen or paper today. Just pick an edge of your object and "draw it" with your eyes. You can also "draw" photographs or other 2D references.

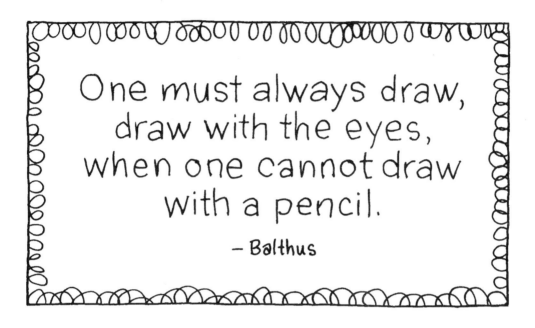

One must always draw,
draw with the eyes,
when one cannot draw
with a pencil.

– Balthus

Extra Credit: Draw the things around you a second time using your index finger. (Hint: It's easier if you close one eye.)

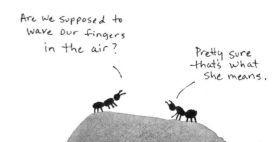

Are we supposed to wave our fingers in the air?

Pretty sure that's what she means.

Take Inspiration from ???

"Creatures" are everywhere. They're in plant shadows, sidewalk cracks, peeling paint, fire hydrants, building ornamentation, clouds, water marks, and trash... when you start looking you will suddenly see them everywhere, too!

See the resemblance?

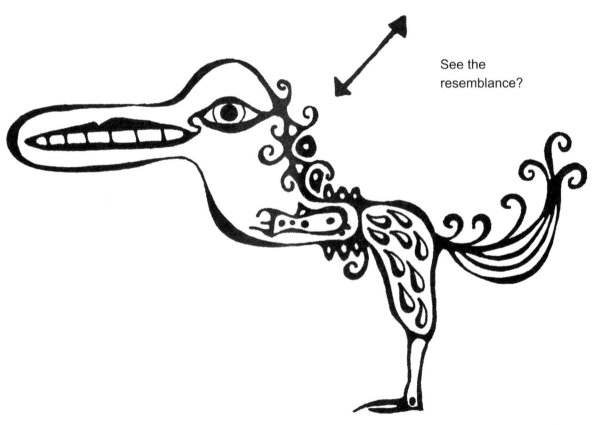

Assignment: Take a 10-minute walk around your neighborhood and draw any "creatures" you see in the space below.

Squeen: An Introduction

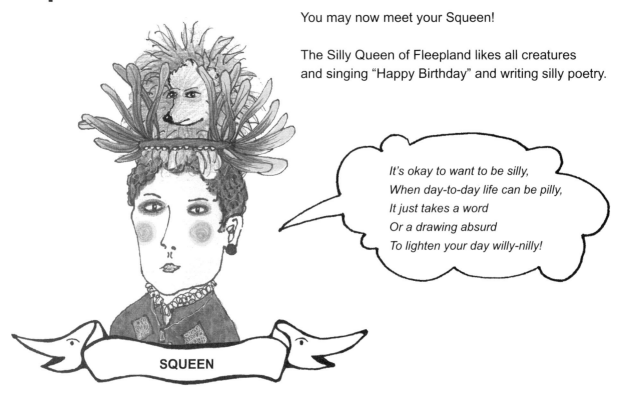

You may now meet your Squeen!

The Silly Queen of Fleepland likes all creatures and singing "Happy Birthday" and writing silly poetry.

It's okay to want to be silly,
When day-to-day life can be pilly,
It just takes a word
Or a drawing absurd
To lighten your day willy-nilly!

SQUEEN

Your turn!
Write a haiku poem made up of three short lines consisting of 5-7-5 syllables, respectively.

Topic: Your breakfast this morning.

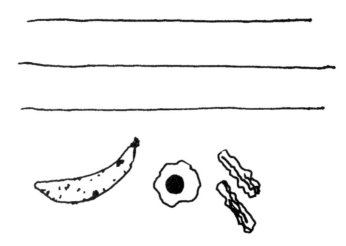

Portrait of the Sking

The Squeen's father is called The Sking. The Sking likes
knock-knock jokes and having his portrait drawn.

Draw two portaits of the Sking in the frames below,
one blind contour and one with your non-dominant hand.

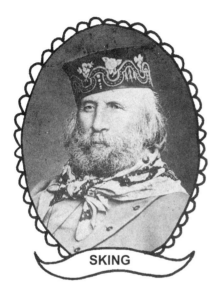

SKING

Blind Contour

Wrong Hand

Now write Sking a new knock-knock joke:

Transform the Blob

This is a "blob," a random shape from "something." Your job is to turn it into something else — a person, a place or a thing.

Extra Credit: Play around with adding cross-hatching and "little dots and hairs" to add shading, dimension, and personality to your drawing.

Step 1
Plain shape.

Step 2
Add major details.

Step 3
Add minor details.

Negative Space Play

Noticing negative spaces (the areas BETWEEN or AROUND a thing, not the thing itself), is a little trick to help you draw more accurately. Draw this simple fish three times by following the directions below.

1. First, just re-draw this fish as best you can in the box below.

2. Here, don't draw the fish itself but just darken the areas around it (negative spaces).

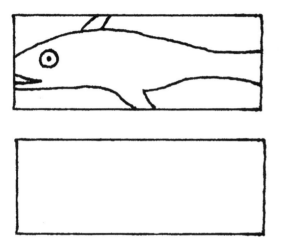

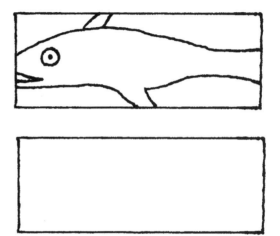

3. Now, repeat Step 1, but pay more attention to the negative spaces while drawing.

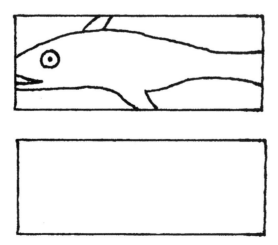

Sidewalk Cracks

This is a photo of a crack in a sidewalk. Look at the image while you slowly turn the book around 180 degrees. Did you see something? A monster, an animal, or a face? If you don't see anything right away, turn the book another 180 degrees. When you see something, "finish" what is already started (drawing directly on top of the photo).

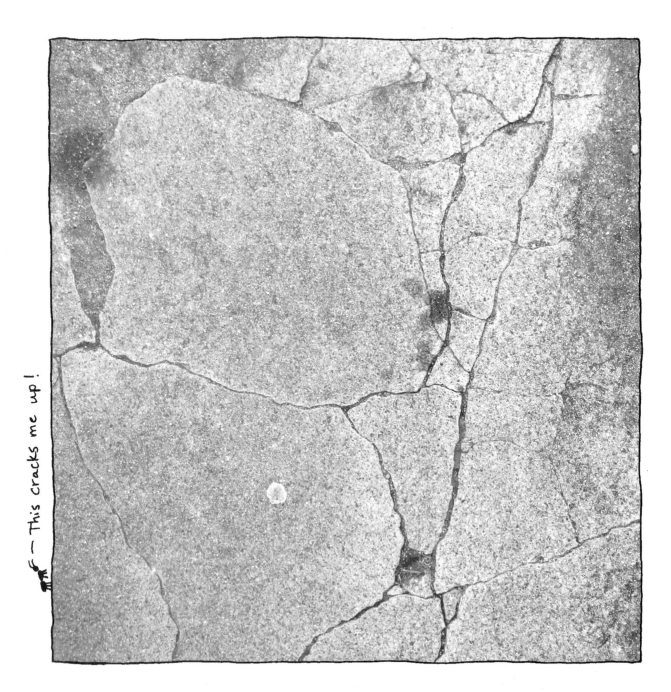

← This cracks me up!

Blinds and Cheaters

Re-draw the faces below twice; first as a blind contour and then as a "cheater blind." (Cheater blinds are almost exactly like blind contours, but you can glance at your paper two or three times).

	blind contours	cheater blind contours

A Mindmap

Fill in the circles below with the first words or images that pop into your head. Start from the middle circle (SILLY!) and move out from there, working as quickly as you can to fill all the circles.

SILLY!

Draw the "Leaves"

The best thing about trees in Fleepdom are their leaves. They're not LEAVES, exactly, but sort of, well, birds, elephants, and alligators. (They just look like leaves from a distance.)

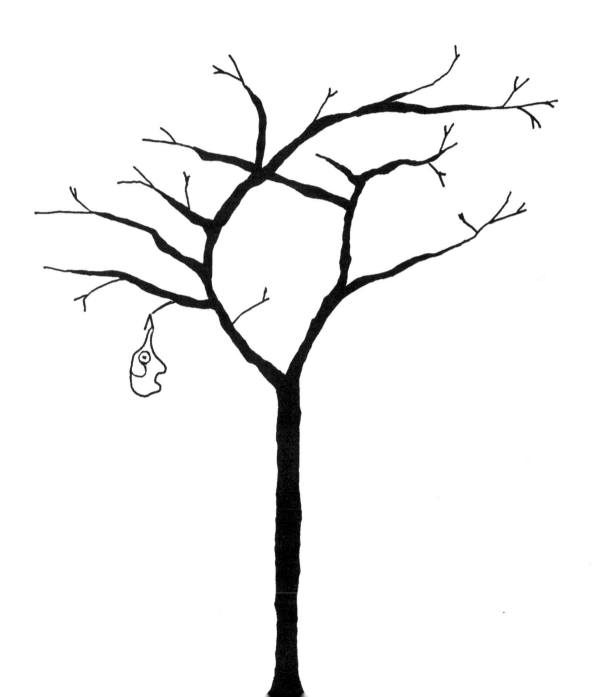

Arrange shapes here.

Shape-Shifters

This assignment is mostly a "seeing" exercise. Cut out the four shapes below and place on a dark table, or the space, left. Arrange them to create something else — a figure, a face, an animal, etc. Now, rearrange the parts to create something new. Repeat a third and even fourth time.

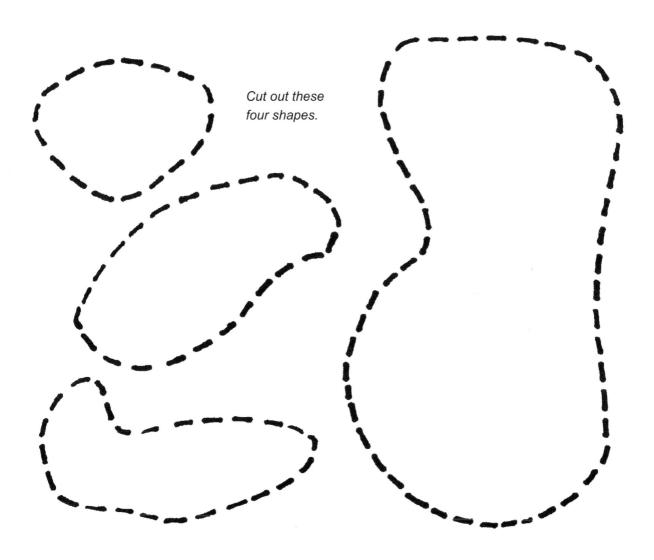

Cut out these four shapes.

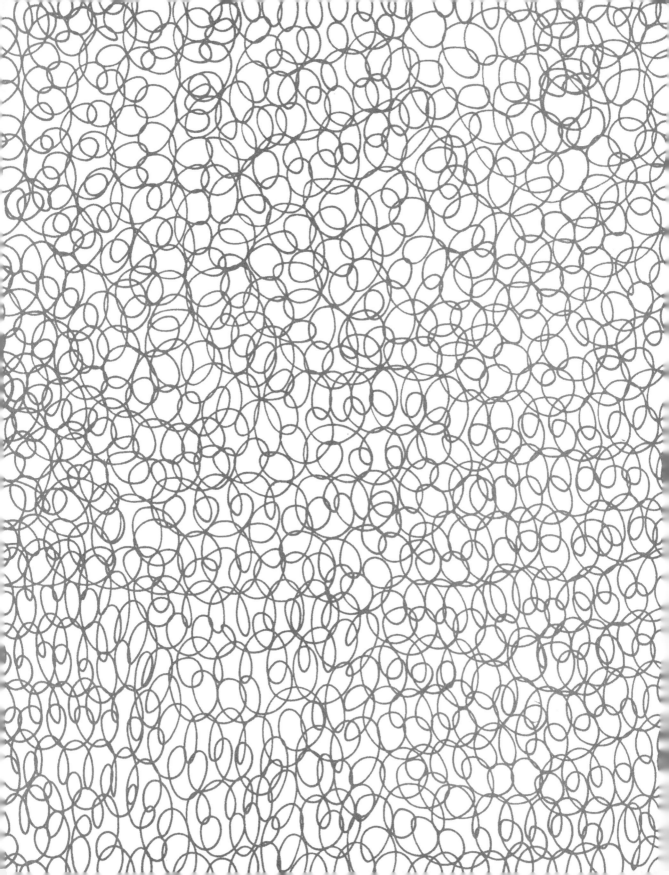

Shape Shifters Extra Credit: Make thumbnail sketches of some of your configurations.

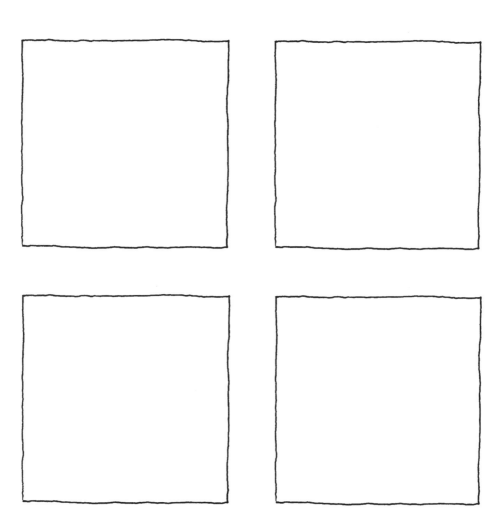

A Saspy Sipper

The Sking really enjoys a good saspy* at the end of a long day, but it must be served artistically or he gets his feelings hurt. Your assignment is to design his drink-topper by copying at least five of the items below (you can make them bigger or smaller, or repeat items as often as you like).

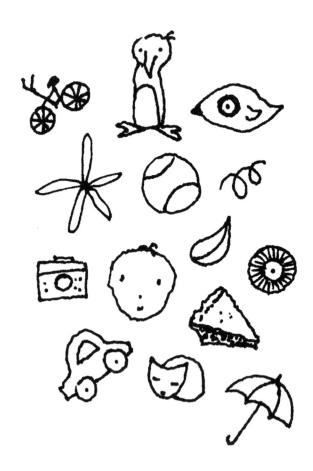

Extra Credit: Add five more items of your own design to the mix.

* A saspy consists of club
soda and sauerkraut.

Famous Fleepians

The people of Fleepland are well known for their generosity and their rather large bottoms. It's been said that if you have a hankering for a jelly doughnut, all you need to do is ask a Fleepian and they will make one for you before the bell rings.

Here are a few famous Fleepians. Fill in the names and honors on this page. What did they do? And what did they do while doing it?

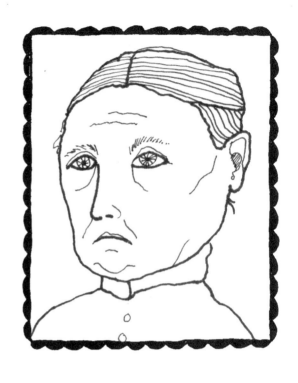

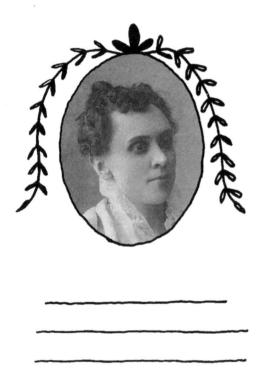

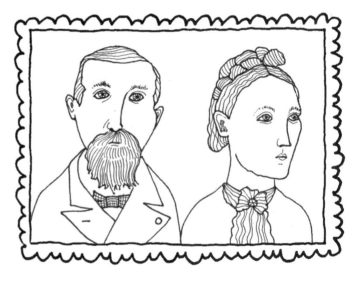

Flauvian Diggerwale
First Fleepian to Juggle While Snoring

Draw portraits of the Kloodledigs and Mr. Diggerwhale by finding some old photographs and doing contour drawings of each.

The Kloodledig Family
Famous for Kloodling and Digging

When in Doubt, Doodle!

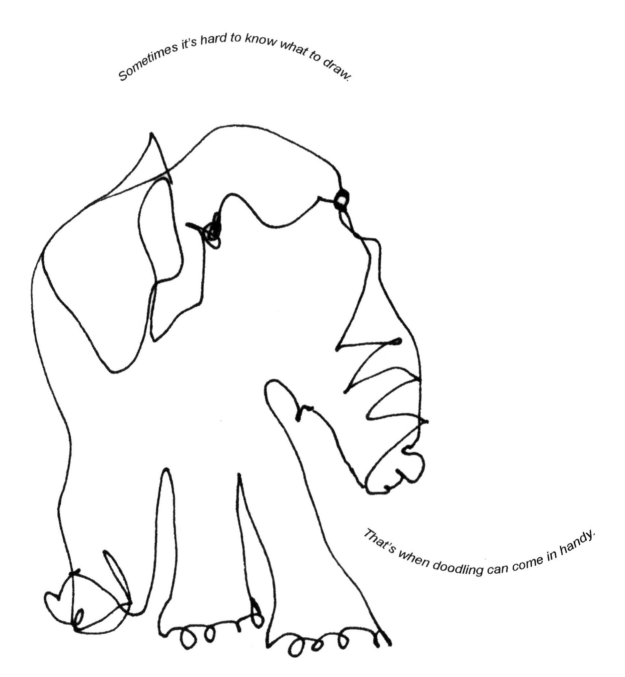

Sometimes it's hard to know what to draw.

That's when doodling can come in handy.

(It gets your hand moving.)

("Doodle" the inside and outside of the elephant.)

Put on your favorite music, and just go!

One-Line Bikes

Draw five bicycles from your imagination using one line only. Imagine a bicycle in your mind's eye and put pen to paper. Once you start drawing, DO NOT lift your pen until you have a "complete" drawing. Try to draw these in a "flowing" manner...not too fast, not too slow...and let your subconscious guide your hand. Think loops!

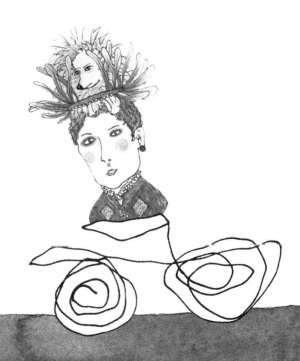

Play with the Lines

Chances are there are several bicycle one-liners from the previous pages that you didn't like all that much. But that's okay, because you can often "save" a mediocre drawing by adding a little flair to the lines.

For today's assignment, pick a bicycle from the previous spread that you don't like, and add weight to some of the lines here and there, round corners, and fill in as desired. As a finishing touch you can grab a thinner marker for even more detailing.

1. **2.** **3.**

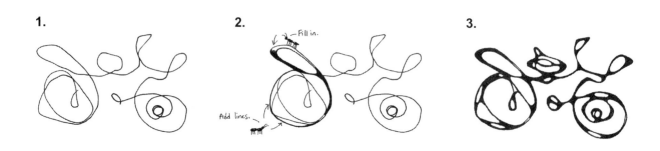

4.

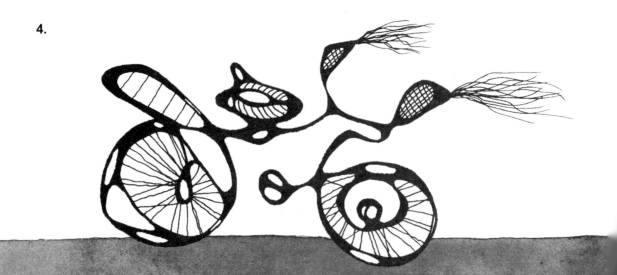

Spin the Top

Draw this top two times using your non-dominant hand.

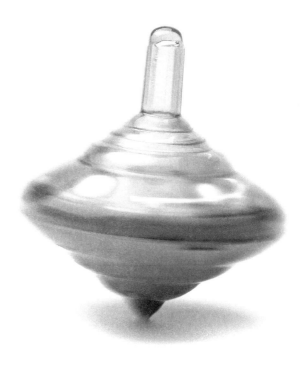

Extra Credit: Spin yourself around
a few times, and then draw!

Fleeptionary

Fleep is the official language of Fleepland. Fleeps
are nonsense words. Made-up words. Silly words!

Write some Fleeps that
start with the last letter of
the previous Fleep Word.

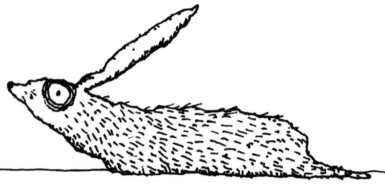

Define your Fleeps here.

fleep

Blob Creatures

This blob was made from a sidewalk crack. Make a creature out of it!

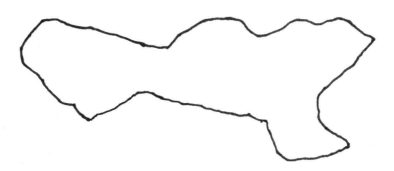

This blob was made from a torn piece
of a sewing pattern. Make a creature out of it!

Make Them Two

Draw each fish a second time, placing it partially behind the first fish. (At first this might seem a little overwhelming, but as with any drawing, pick one thing to start with — such as an eye — and build the drawing line-by-line from there.)

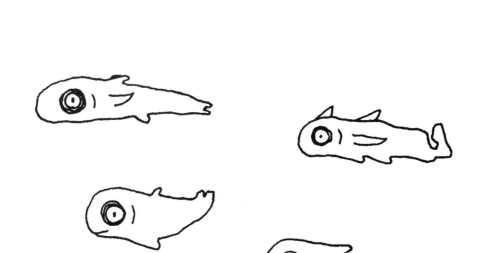

sample

Extra Credit

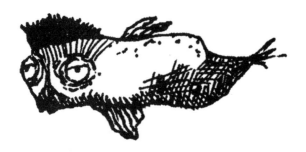

Be Square

Another "seeing" assignment! (Drawing is mostly seeing.) Cut out the two squares, below, and run around peering through the inside square, cropping things (kind of like looking through a camera viewfinder, but it's made of paper instead).

Find something to look at, then spend ten minutes peering through the hole while moving the square to the right, to the left, up, down, closer to your face, farther, etc.

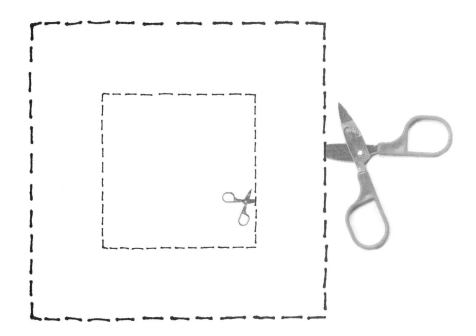

You forgot to tell them to close one eye.

Or that they can look at several objects during their 10 minutes.

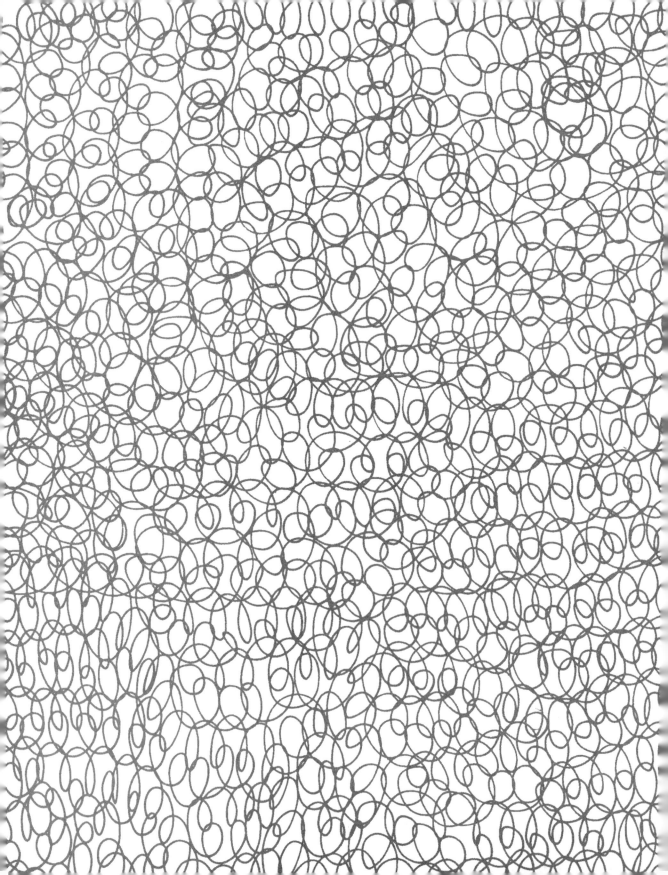

Squint

Look at the photograph below and squint your eyes. Now, un-squint them. Now squint them again. Do you see a difference? When you are in "squint mode," see if you can discern a little more clearly the darker parts, or shadows. (Hint: It might take a while to get the hang of it.)

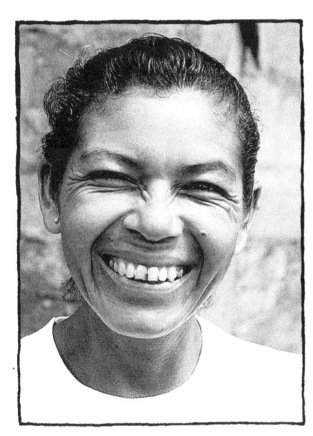 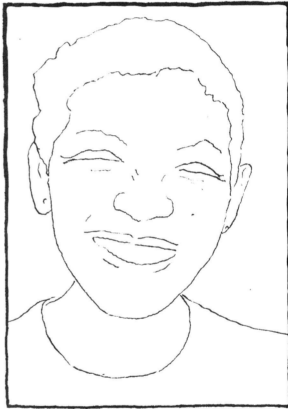

Once you feel you can see the shadows clearly, use a pencil to darken the appropriate areas in the line tracing, right. You are not trying to render the drawing realistically, but just concentrate on recording the lighter and darker areas. (As always, it's best to remind yourself that this is a practice drawing — it's a silly book after all — and that whether you do it "right" or not is not the point of the exercise. The point is to just settle down with the image, squint your eyes, and do your best to darken the shaded areas and leave the lighter areas alone.)

Extra Credit: Look at everything today through squinted eyes...your furniture, your family members, etc.

Add drawn elements to the drips and splotches.

The Class of '12

Using a pen, do four contour drawings of the Squeen's classmates in the box direcly below each photo. Contour drawings are done exactly like blind contours — you pick an edge of your subject and very slowly draw an outline — only now you can look at your paper while drawing. (Aim for a 40/60 split: 40% looking at your drawing, and 60% at the reference.)

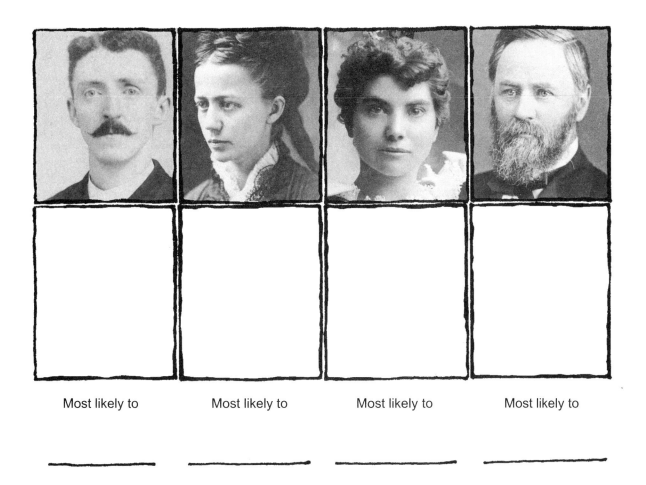

Most likely to Most likely to Most likely to Most likely to

————————— ————————— ————————— —————————

Try to reserve judgment on your results. Remember, you are using pen only, without the chance to erase, and to err is human! If a line goes astray, just reposition and start again. No worries!

Scribble

Scribble all over these two pages for five minutes straight. Do not try to make anything out of your designs...just pretend you are two years old and are just moving that pen around the page for the pure joy of making marks. You can even hold your pen in your fist!

Some of you might find this to be the hardest exercise yet. That's okay, but do try to "let go" now. Work quickly, and really get into it. Just make a big scribbly mess all over!!

Why Scribble? Because you want to pay attention to how you FEEL while scribbling. Does it feel fun? Does it feel weird? Did it start out weird and end up fun?

Scribble with Intention

Now we're going to revisit this woman's face and "scribble" her at least six times.

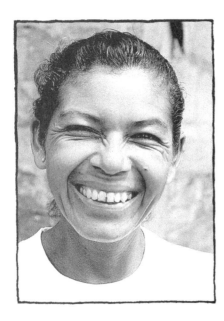

Here's how to do it: Before putting pen to paper spend a moment or two just looking at the photograph. Squint your eyes to get a feel for the lights and darks again. Then, start scribbling, but with INTENTION. Hold your pen or pencil very loosely and work as fast as you can. It's impossible to control much of the outcome, so let it go! (In other words, you are letting your subconscious — not your conscious — mind pick up the clues that will translate onto paper.)

Look at your reference more often than your paper. Scribble more densely in the darker areas and more sparsely in the lighter parts. You are trying to capture the essence of this woman, not the details or a perfect likeness.

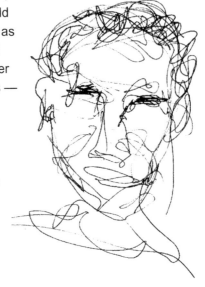

Often you will naturally do these in one continuous line, just because you are working so quickly. But you are certainly free to lift your pen as much as needed to reposition, etc. You will end up with many drawings that look like scribbly messes instead of faces, but keep trying.

Whoa. She's really into scribbling.

Yep.

Connect the Dots

Connect the dots using straight, curved, jaggedy, or loopy lines.
Don't plan, just connect.

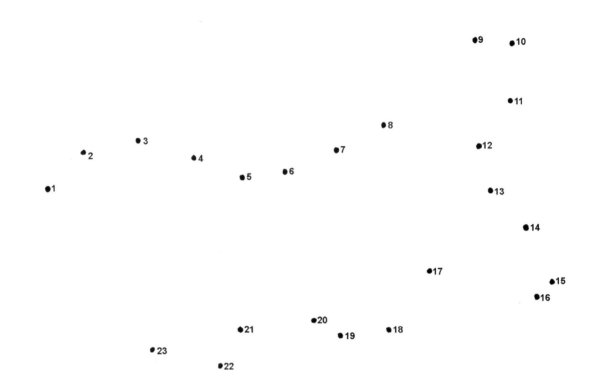

Here are a few examples:

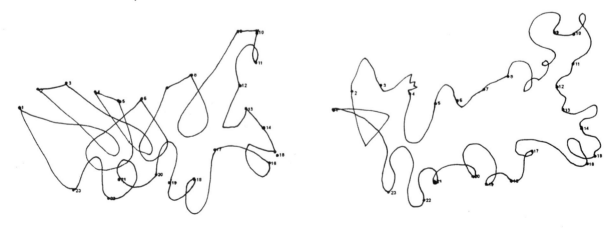

Now create a new drawing *inspired by* your dot-to-dot drawing, left. (In other words, just use it as a starting point, and let the new drawing morph and change into something completely different, if that's where it takes you.)

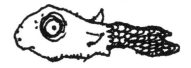

Fleepland Flora and Fauna

Fleepland is teeming with the most unusual plant and animal life, as you can well imagine. Complete the "Leaf and Flower Index" by drawing plant species found and imagined in the Land of Fleep, right.

Draw the twelve-toed rock-hugging hippoflamingus, below.

Leaf and Flower Index

A Silly Saturday

Do these things on a Saturday afternoon, just for fun.

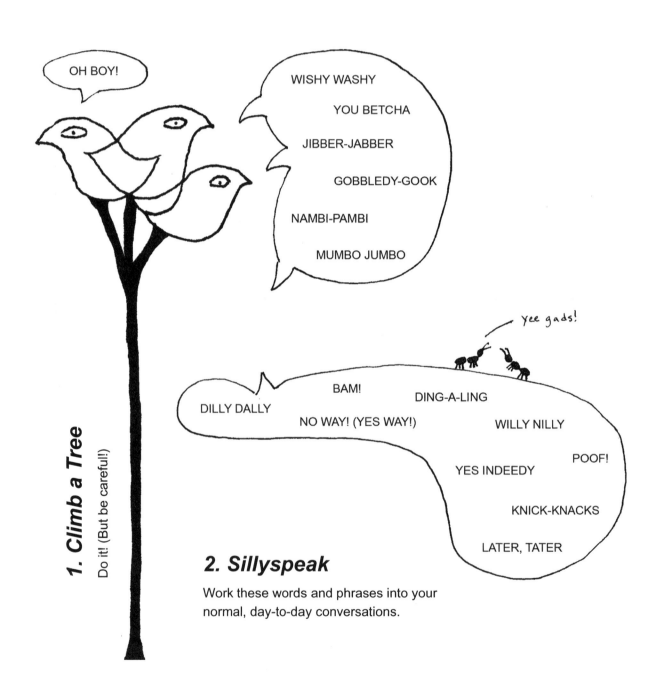

OH BOY!

WISHY WASHY

YOU BETCHA

JIBBER-JABBER

GOBBLEDY-GOOK

NAMBI-PAMBI

MUMBO JUMBO

yee gads!

DILLY DALLY

BAM!

DING-A-LING

NO WAY! (YES WAY!)

WILLY NILLY

POOF!

YES INDEEDY

KNICK-KNACKS

LATER, TATER

1. Climb a Tree
Do it! (But be careful!)

2. Sillyspeak

Work these words and phrases into your normal, day-to-day conversations.

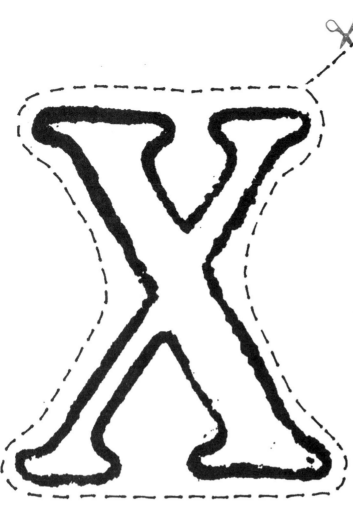

3. Marks the Spot

It really does. Cut out this "X" and mark a spot. Stick around for awhile and watch!

4. Cut Out These Eyes

... and stick them on something, inside or outside. Take a picture. Do it again.

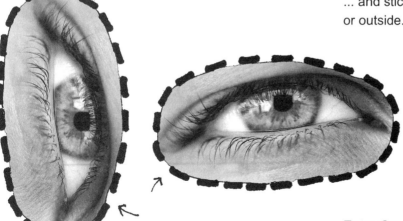

Extra Credit: Draw yourself doing one of these activities.

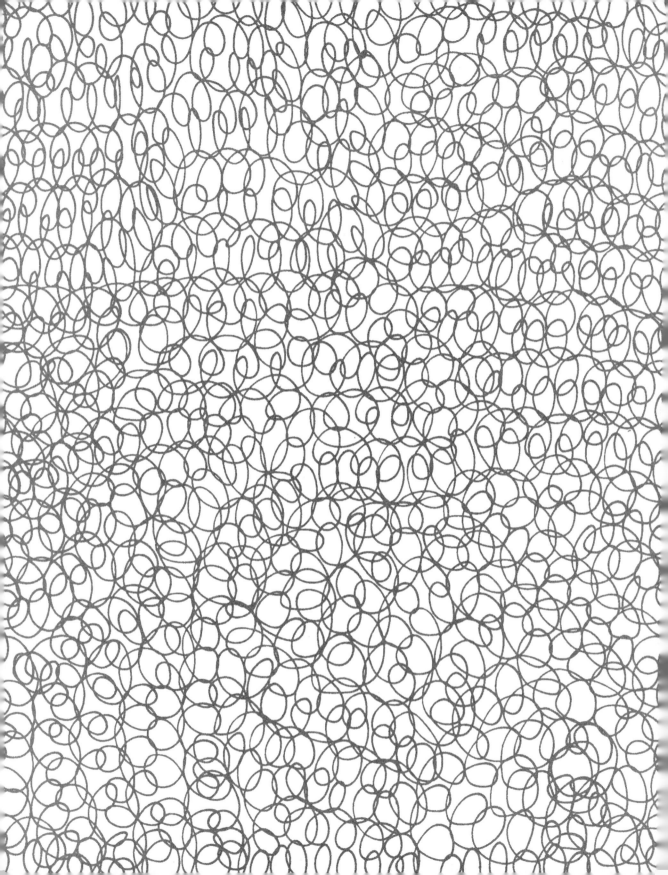

Recess!

Take some time today to look through
the drawings you have created so far.
Which exercises did you like the most?
Which exercises caused you to feel
most out of your comfort zone?

By being aware of your preferences you can
more positively shape your drawing routine.
Write down any thoughts in the space below.

Parakeet Play

Find a photo reference of a parakeet (either online or at the library) and draw it three times: one contour drawing, one scribbly drawing, and a one-liner.

— You can do it!

The Mr. and The Mrs.

Fill in the blanks.

This is _____

Her favorite hobby is _____

Her hero is _____

Favorite Color _____

Favorite Dinner _____

Favorite Drink _____

Favorite Sport _____

Favorite Animal

Favorite Superhero

Favorite Book

Favorite Movie

Favorite Quote

This is _____

His favorite hobby is _____ _____

His hero is _____

Favorite Color _____

Favorite Dinner _____

Favorite Drink _____

Favorite Sport _____

Favorite Animal

Favorite Superhero

Favorite Book

Favorite Movie

Favorite Quote

Bananas for Breakfast

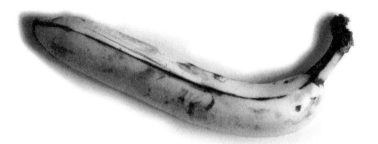

Sking always has bananas for breakfast, but today Squeen and her triplet cousins decided that they would each like one as well.

1. Go get a banana.

2. Open it up and take a bite.

3. Hold it in your hand and draw it four times using the method indicated.

4. Finish banana.

Knock, knock.
Who's there?
Waiter.
Waiter who?
Waiter minute while I tie
 my shoelaces.

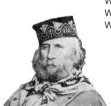

scribbly banana

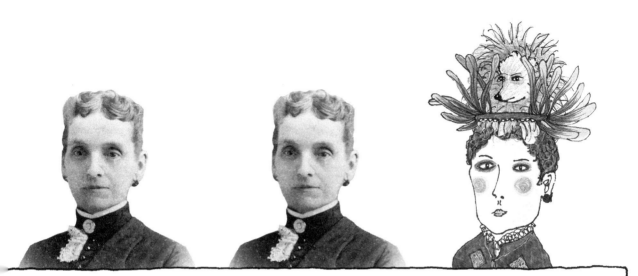

blind contour banana contour banana wrong-handed banana

Four Mini Sillies

Follow the directions in each box.

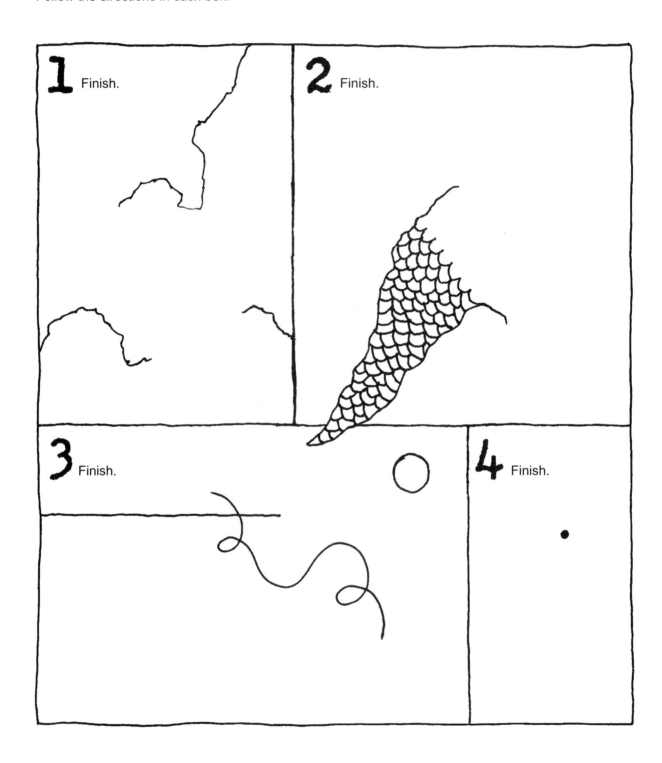

1 Finish.

2 Finish.

3 Finish.

4 Finish.

Solve the Mystery

Fill in the rest of this picture. What is holding up the branch?

Exquisite Corpse Book

1. Draw people, places, or things on the next eight pages. The tops can be the tops of things and the bottoms can be the bottoms of things.

2. Be sure that your drawings line up with the two tiny vertical lines on the middle axis, so that when you cut the pages in half later, the drawing on other pages will line up too.

3. Cut along the dotted lines.

4. Flip the pages back and forth to make many different combinations!

"Creativity is a natural extension of our enthusiasm."

—Earl Nightingale

Enthusiasms

Spend 10 minutes recording some of your "enthusiasms."
These can be silly, serious, imaginary, or mundane. You can
communicate your ideas through writing, drawing, or some
combination of the two.

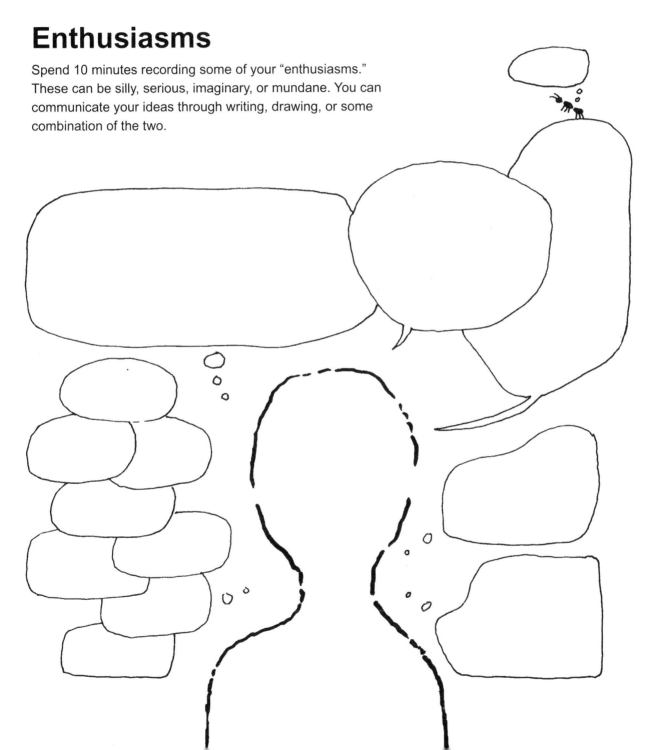

More One-Liners

Draw Natalie the Cat three to five times using one line only, but this time use the photo for reference. Look back and forth at the photo and your drawing as you go. Remember, do not lift your pen until you have a "complete" drawing.

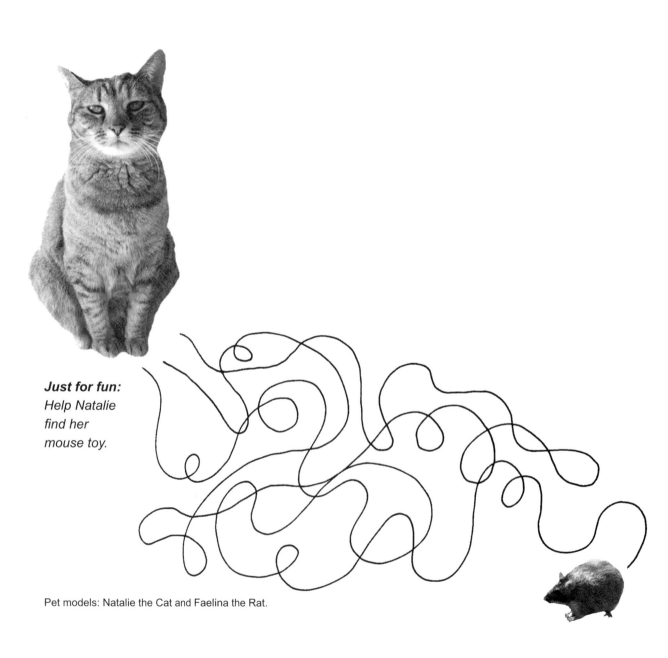

Just for fun:
Help Natalie find her mouse toy.

Pet models: Natalie the Cat and Faelina the Rat.

Try slowing down a bit this time, giving yourself a little more time for choices (but still letting your subconscious guide your hand). Be sure to give her eyes!

Finish This Drawing

Incorporate at least six of the following elements into the image (from references or your imagination).

FLOWER

FISH

FEATHER

FOUNTAIN

GIRAFFE

CAR

PERSON

PLANT

PHONE

DOOR

PITCHER

PICTURE

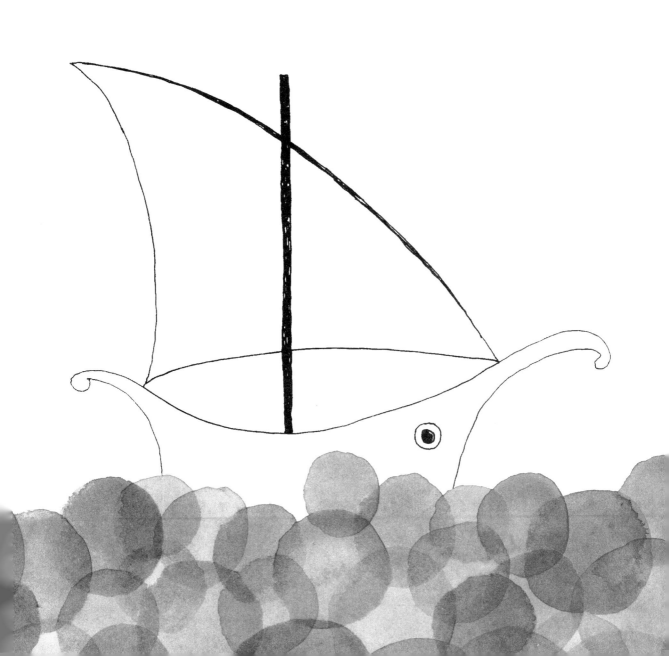

Design Squeen's New Hat

Design the Squeen a brand new hat using any combination of the elements on this page.

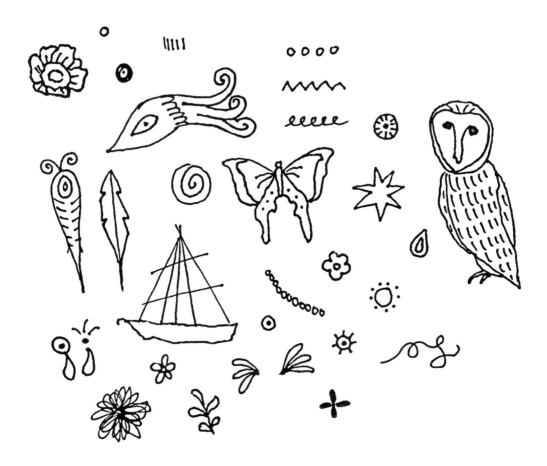

Extra Credit: Add your own designs to the mix as well.

The Squeen's fabulous new hat!!

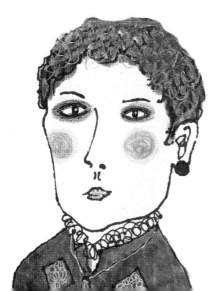

More Blobs

Turn these shapes into something else.

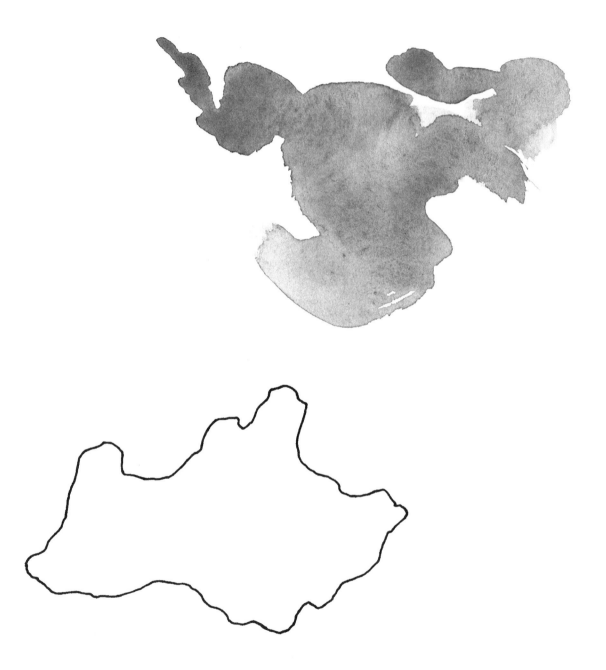

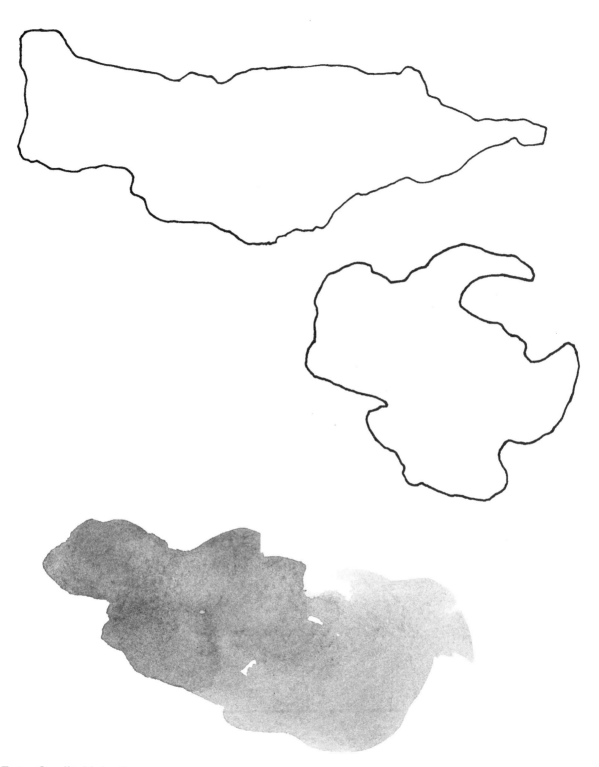

Extra Credit: Make them
interact with each other.

Step by Step by Step

Make a drawing in the space at right, by following the steps in order. Don't look at all the prompts at once and plan your entire image; instead, just allow yourself to look at one prompt at a time. This forces you to make a commitment and then live with it as you try to incorporate the next prompt (a good problem-solving exercise).

1. In the box, draw one horizontal line between 2 to 4 inches long.

2. Draw three vertical lines anywhere you like (any length).

3. Draw a horse somewhere in the box.

3. Draw five curved lines.

4. Add three circles or half-circles.

5. Now add a rabbit.

6. Finish with details of your choice.

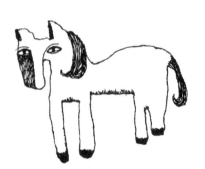

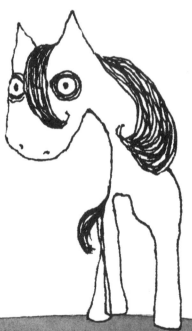

Line Weight Play

Draw a face using at least three different weights of pens. You must use all three pens in drawing your face. You can stylize it, but don't forget to refer to life and photo references to help you out. Draw eyes, nose, eyebrows, hair, mouth, ears, wrinkles, and whatever else you want to complete your face.

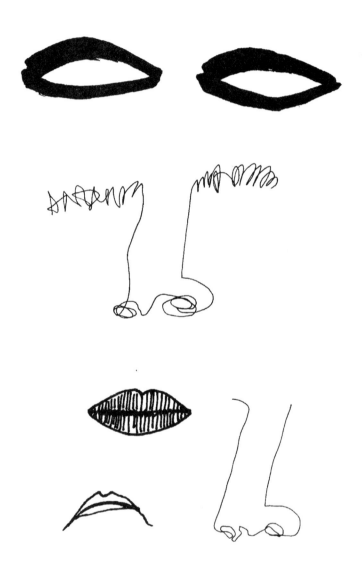

Extra Credit: Try drawing the different elements in different ways, such as a one-liner nose or a wrong-handed mouth. Keep adding features using as many different drawing styles as possible.

Draw a Trog

As everyone knows, trogs are very rare creatures who live deep inside the dark forests of Fleep.

That's where you come in. Since trogs are so shy, we have yet to actually discover what one looks like. It's your job to draw a trog from some combination of the elements below (plus whatever other things you'd like to add).

Elements you can use (a partial list):

wing(s)	horn(s)	fingernail(s)
whisker(s)	long fur	tail(s)
spike(s)	facial hair	feather(s)
snout(s)	claw(s)	bulbous knee(s)

Extra Credit: Go online or to the library and research animal features, and then add more elements in the space above.

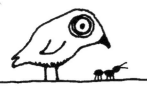

TROG

House and Yard

Get out your scissors and a magazine! Glue down four to six cutouts of tables, chairs, beds, people, animals, plant life, etc. Add drawings around the collaged elements to complete the scene.

Scribble Search

Find something — a person, place, or thing — in the scribbly mess below. (If you don't see anything after a moment, turn the book 90 degrees.) Hint: Sometimes all you need to do is add an eye.

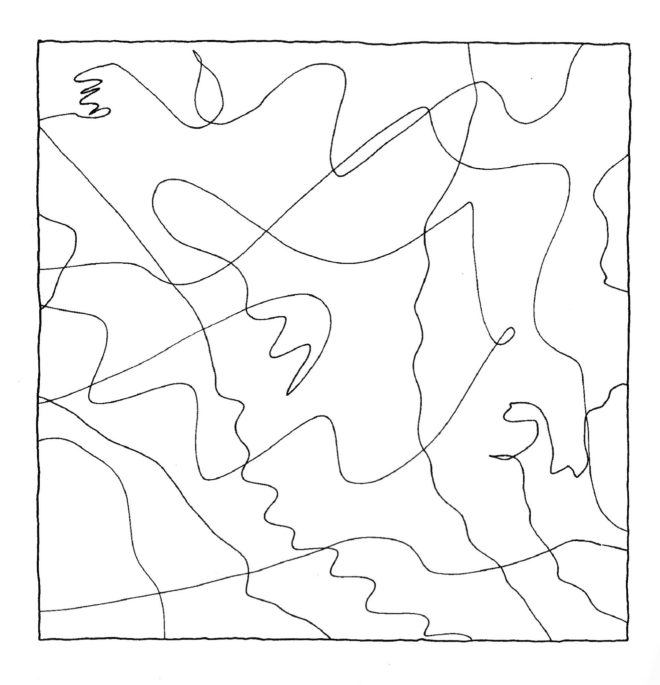

Solve the Equation

$$x + y = z$$

If

x =

and

y =

... then what does "z" look like?

Do a contour drawing combining elements from both the turtle and the bird guy. (Pick an edge and slowly copy what you see....)

z =

It's a Drawing

Here's how it works: Draw the following 20 things. You can draw them on separate pieces of paper, in this silly book, or on your forearm, your choice! Use any media you wish.

☐ A blind contour of a toothbrush.

☐ A blind contour of a shoe.

☐ A blind contour of a plant.

☐ A blind contour of your stove.

☐ ☐ ☐ Three scribbly drawings of items you can see while sitting on your couch or favorite chair.

☐ ☐ ☐ ☐ ☐ Draw five shapes from your imagination, about the size of a large coin. Turn them into something.

☐ One-liner of a human face.

☐ One-liner of a fish.

☐ One-liner of a tree.

☐ ☐ ☐ Do three contour drawings of objects of your choice (from life). Suggestions: kitchen items, toys, furniture, etc.

☐ Draw an face from a photo or life with your non-dominant hand.

☐ Draw the same face immediately afterwards with your dominant hand.

Check off the boxes as you complete each drawing. Now... go!

Scavenger Hunt Drawings Here

Scavenger Hunt Drawings Here

Phew!
You did it!

Finish the poster.

Found!

Complete the Blob

This is the same blob shape shown in four different orientations. Without turning your book around this time, see what you can make from each of the shapes.

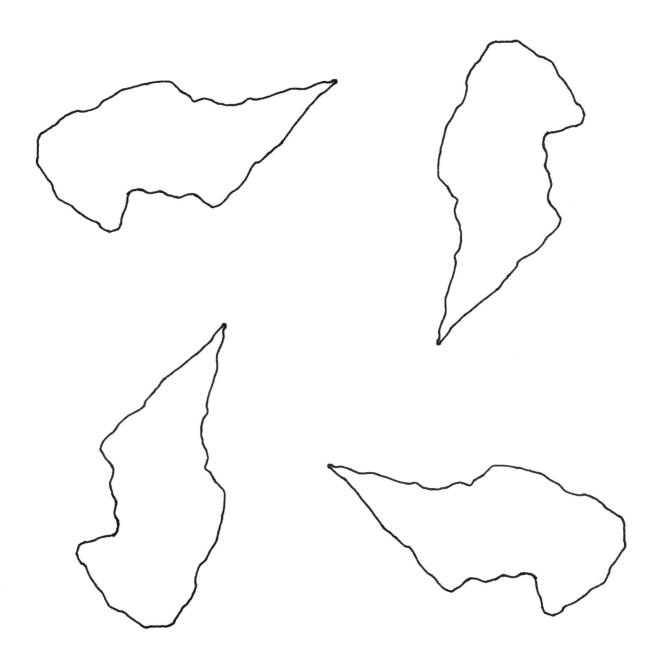

Combine Unrelated Images

Using photo references you find online or at the library, combine "flamingo" and "girdle" into one drawing. Use the space below to work out your ideas with both words and images (think of this part as "note-taking"). Try at least three different variations before going to the finish.

Final drawing here.

Add to the Image

Using any media you wish, add at least four items from the list, below. (If you don't know how to draw something, try looking at photo references in a book or online to get you started.)

bottle

stove

car

bicycle

rose

leaves

letter forms

mug

animal

bug

spoon

pillow

chair

house

book

eye

ear

mouth

dangly cat earrings

What Do You Make of It?

Choose from one of these three options:

1. Turn the book around and around until you "see" something — an animal, a face, a toaster, etc. Then, complete what is already "started" (even if it's upside-down on the page). Repeat as many times as you like to create multiple drawings within the shapes.

2. DON'T try to turn it into anything "real." (This is the option to choose if you are feeling a bit overwhelmed with it all today.) Just turn on some music (or a podcast) and doodle it!

3. Challenge yourself to figure out how to turn this design into ONE cohesive drawing.

Now draw your own scribbly design, and "finish" it.

Scribbly Cups

While at a restaurant or coffee shop, scribble
five to ten coffee cups in the space below.
Look at your reference 80-90% of the time.

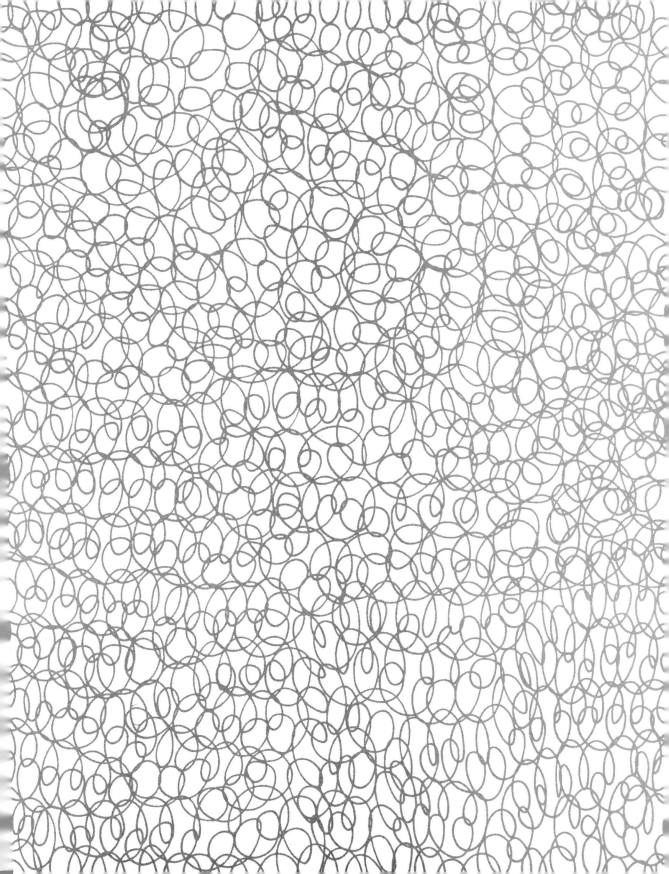

Game Time

Find a friend and play the game! You will need one die and a pen or pencil.

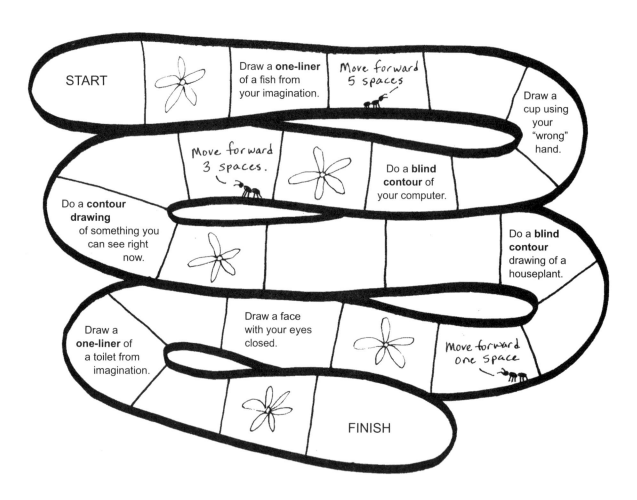

START

Draw a **one-liner** of a fish from your imagination.

Move forward 5 spaces

Draw a cup using your "wrong" hand.

Move forward 3 spaces.

Do a **blind contour** of your computer.

Do a **contour drawing** of something you can see right now.

Do a **blind contour** drawing of a houseplant.

Draw a face with your eyes closed.

Draw a **one-liner** of a toilet from imagination.

Move forward one space

FINISH

Cut out the faces...these are the game pieces.

Game Drawings Go Here

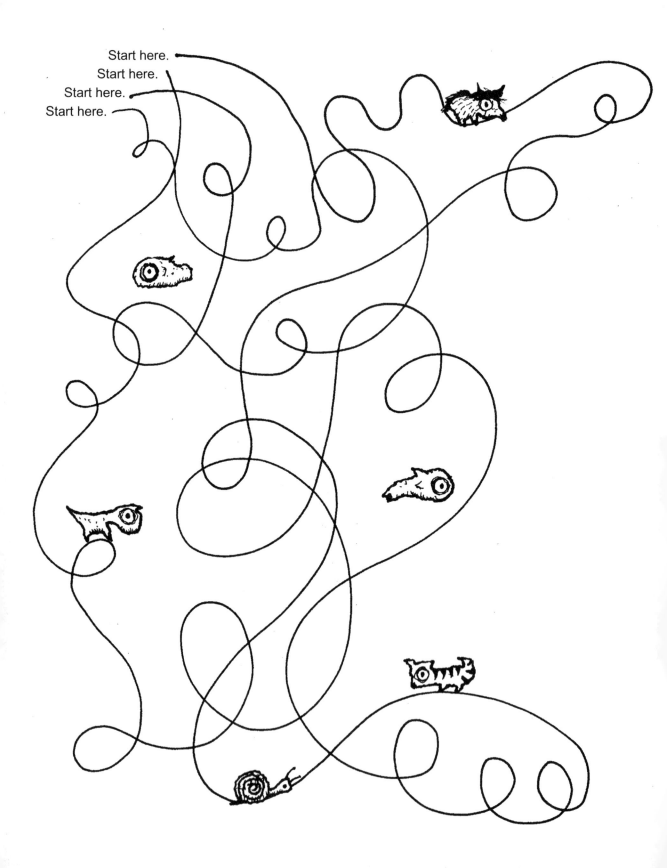

Start here.
Start here.
Start here.
Start here.

Finish the picture.

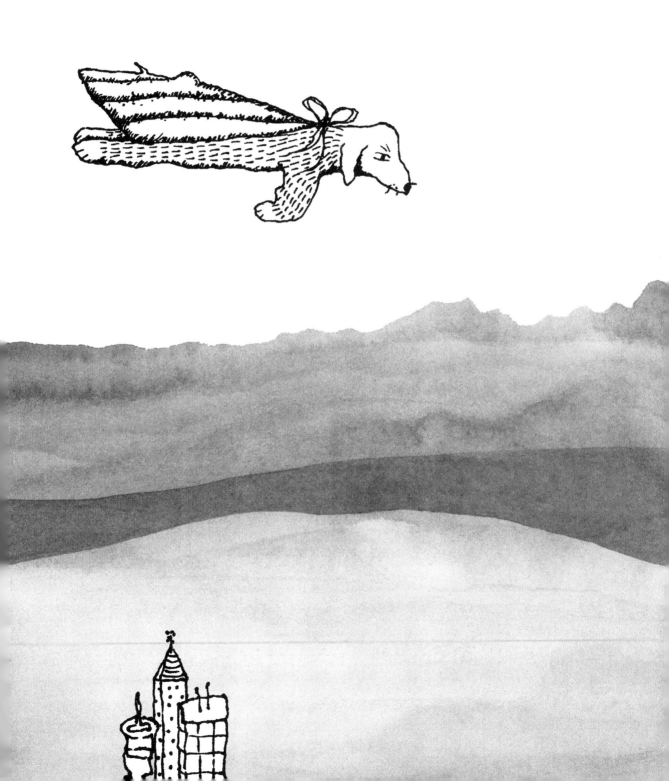

Shading Imaginary Creatures

How do you shade something that you have created from your imagination? Here are some things Squeen tells herself when deciding where to put the shading on imaginary drawings.

• ALL drawings are made up of shapes, such as cones and spheres. The shading of a sphere-like chest, then, would be similar to a shaded drawing of a sphere.

• It's a pretty sure bet that there is a shadow under the neck, under a wing, under the eyes... also, any place where one part MEETS another will often need a shadow (think armpits on a human being, for example).

• It helps to imagine an imaginary sun shining on the imaginary creature from an imaginary angle. That way, if you get stuck, you can say to yourself, "Oh, yeah, the light is shining from here!"

With pencil or pen, add shading to these Ploodangles.

Try not to fret as you practice shading imaginary things. If one of your shadows seems oddly placed once completed, you can quickly adjust your thinking and decide that it is a patch of fur instead!

Connect the Dots

As you can see, these dots are not numbered. So, it is up to you to decide how you would like to connect them. Use straight, loopy or jaggedy lines. Don't think, just connect!

Extra Credit: Even though you weren't trying to draw anything specific in the above exercise, see if you can find something in your design, such as a face or animal. Add details (such as eyes, teeth or hair) to "pull out" an image.

More "Leaves"

Draw in the leaves of these two different variety of trees. (Remember, leaves in Fleepdom can be just about anything!)

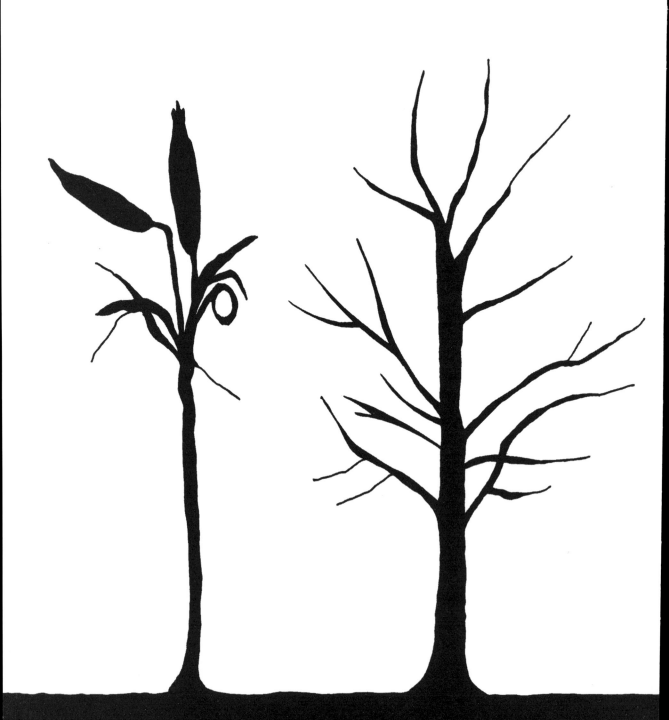

More Contours

While looking at the photo of the young boy, below, pick a point to start, put your pen to paper and SLOWLY move your pen along the line or edge of the image (including facial features). Look at your paper about 40% of the time and the reference about 60% of the time. You are free to lift your pen as often as you need to.

Don't forget to breathe, and let the negative space help you!

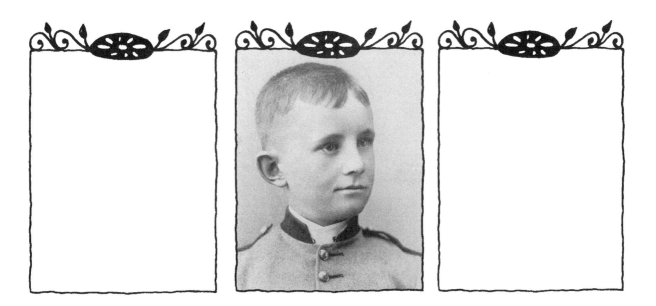

Extra Credit: Draw one with your dominant hand and one with your non-dominant hand.

Finish the Picture

Ask yourself questions to get your ideas flowing...
Where is he? What is she doing? Why here, why now?

Do This on a Day When You Don't Know What Else to Do

1. Write your name backwards. _____

2. Pick up 20 things from around the house, and either throw them out or put them away. List the items below. (Tip: a piece of lint can count as one "thing.")

3. Call a friend and talk for precisely SIX minutes. Tell her why you are calling, and take notes and doodle during the conversation in the spaces below.

```
Notes

```

4. Ask a friend to draw this cat:

(Have them draw it in the space below and sign their name.)

Doodles

Elephant Herd

In the space below, draw six to ten one-liner elephants from your imagination.

Remember, it sometimes helps to talk to yourself while working: "Hmmm... elephants have trunks, big ears, funny feet, are wrinkly," etc. Don't be afraid to overlap lines and loop them all around... the loopier, the better!

Extra Credit: Draw the entire herd in one line (i.e., connect all the elephants).

Catalog the Day's Minutiae

Spend 10-15 minutes cataloging the mundane and minute goings-on of your day. This exercise should be done in the late afternoon or evening so that your "day" is mostly behind you. Details, please!

Woke up.

Finish this drawing.

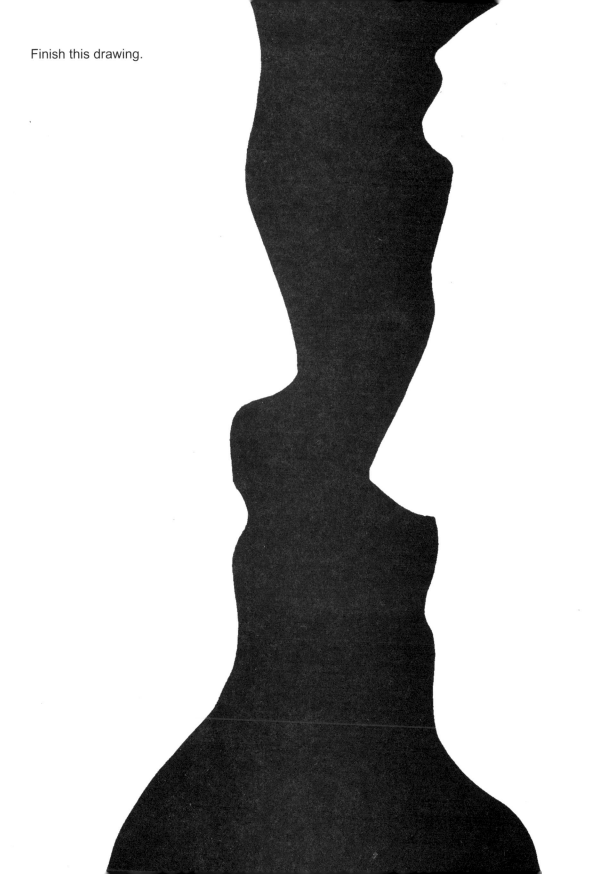

Parade of Silly People

People in profile! Add more silly people to the parade. Make a blob shape by starting with the nose, then the head and legs (no arms necessary). Then, add eyes and details...Instant Silly Person!

END

Step by Step

Add lines and shapes to the box in the order given below. Don't add element #2 until you have completed adding #1. (It's best if you can hide the prompts from your view right now and only reveal the next step once you have completed the previous one.)

You are free to interpret each prompt however you like.

1. Draw three longish lines.

2. Add one large circle and one small circle.

3. Add 5 squares, any size.

4. Add 12 small vertical lines.

5. Add a very large person, place, or thing.

6. Finish the design in a way that makes you smile.

7. Color!

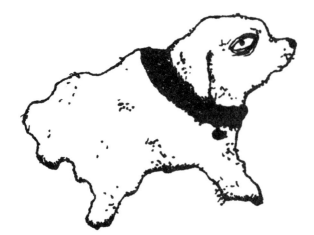

Draw Squeen a New Pet

Using a pencil and your eraser, draw (and erase!) the Squeen's newest pet from a photo reference found in a book or online (your choice of animal). First try to get the proportions as accurate as possible, then add the details. Look at your reference MORE OFTEN than you look at your drawing. Squint your eyes to help you with the lights and the darks. Take just 10-15 minutes to do this exercise.

Extra Credit: Once you've drawn your animal, take some time to really look at the drawing you've created. Get up from the table and look at it from a distance.

Does a leg look a little short compared to your original reference? Or the snout a little long? You are not judging yourself, of course, but only observing the drawing. Take the time now to adjust your drawing so that it's as accurate as possible.

Good luck!

Silly Haiku

Write a haiku poem (with lines of five, seven, and five syllables).

Your topic: Falling asleep.

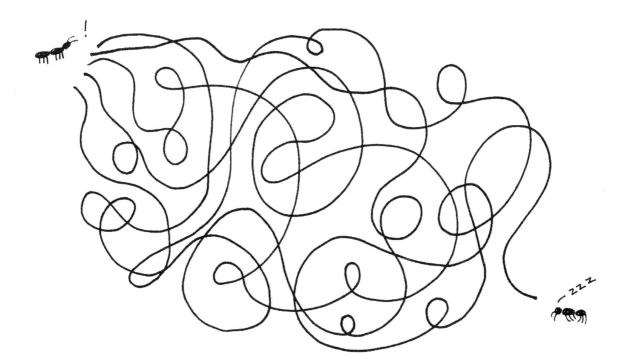

Finish these drawings.

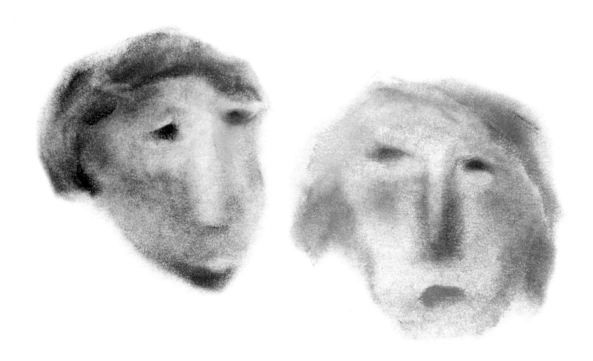

Color the Design

Color the shapes in using the colors indicated.

1 - dark blue 5 - red
2 - green 6 - orange
3 - purple 7 - yellow
4 - light blue 8 - pink

Extra Credit: Abandon the color guide and instead color any image you see in the pattern.

Play with Your Food

Raid your cupboards for two raisins, two grains of rice, or two lentils (just something small). Place them as "eyes" anywhere in the larger oval shape (left). Look at it for a moment. Now move the food bits so that they are really far apart from each other. Now move them so they are very close together. Now move one "eye" up and one "eye" down. Etc.

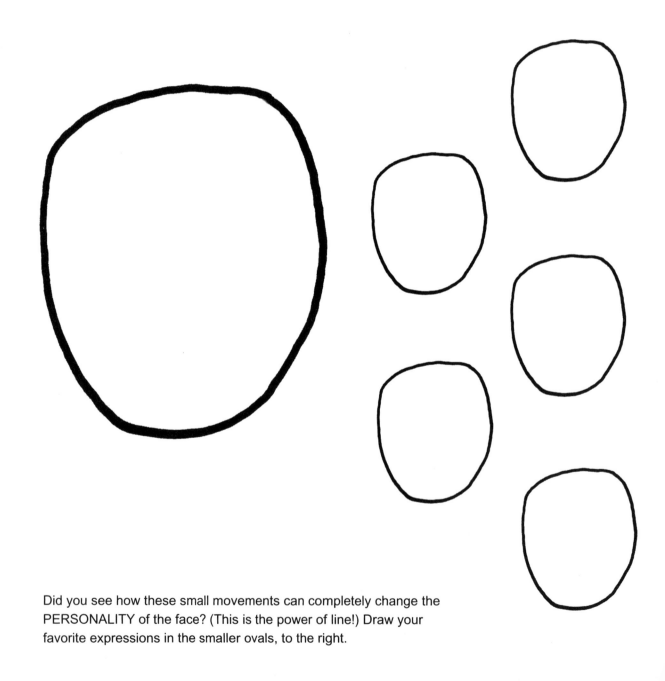

Did you see how these small movements can completely change the PERSONALITY of the face? (This is the power of line!) Draw your favorite expressions in the smaller ovals, to the right.

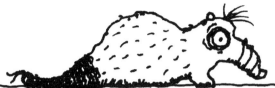

Draw the
Textures of Things

Draw the textures of a rug or carpet.

Gravel or driveway textures.

Close-up texture of a leaf.

Details of an outside wall or fence.

Something in your refrigerator.

Fill three to eight boxes with close-up drawings of patterns and textures found around your home.

Don't worry if your textures aren't recognizable, but just try to capture the "feel" of the surfaces. When drawing, look at your reference MORE OFTEN than your paper. Use any media you wish.

Texture on an inside wall.

Pet fur.

Extra Credit: Fill in ALL the boxes.

Your bedspread.

More Negative Spaces

Draw the branches below, paying more attention to the shapes BETWEEN them when drawing.

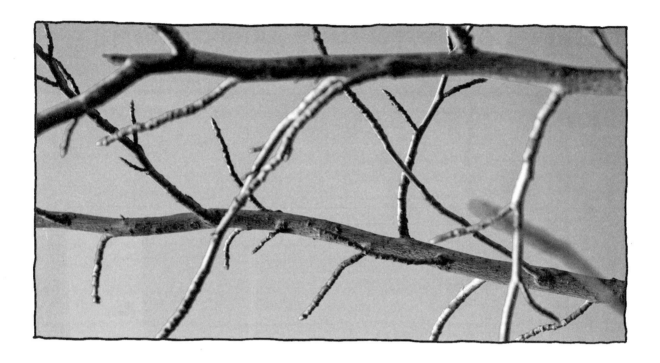

No Peeking

Do several blind contour drawings of a stack of books.
(Remember, blind contours are drawn without looking
at your paper.)

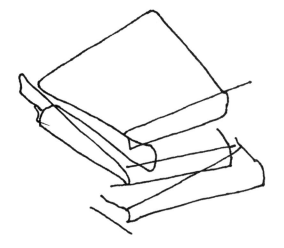

The Flag of Fleepland

Design the Silly Flag!

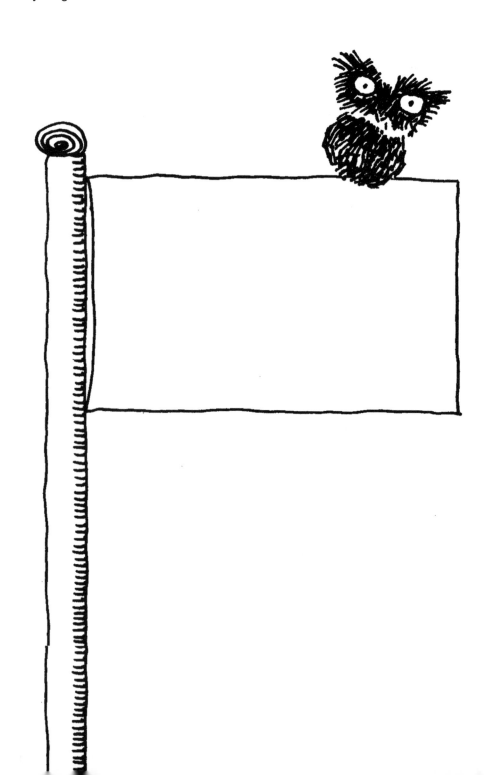

Draw the bees.

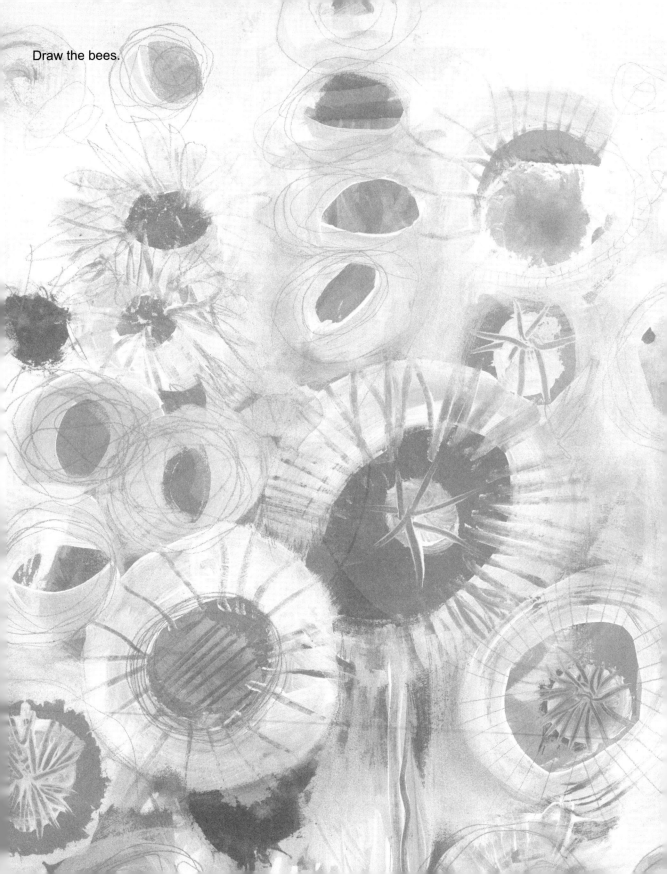

Draw a Cartoon

Draw a cartoon panel about your morning.
Stick figures okay. (In fact, stick figures mandatory.
Stick figures = fun!)

Draw a dog pretending to be a horse pretending to be a chicken.

Add to these splotches to make a person,
a place, an animal, or a thing.

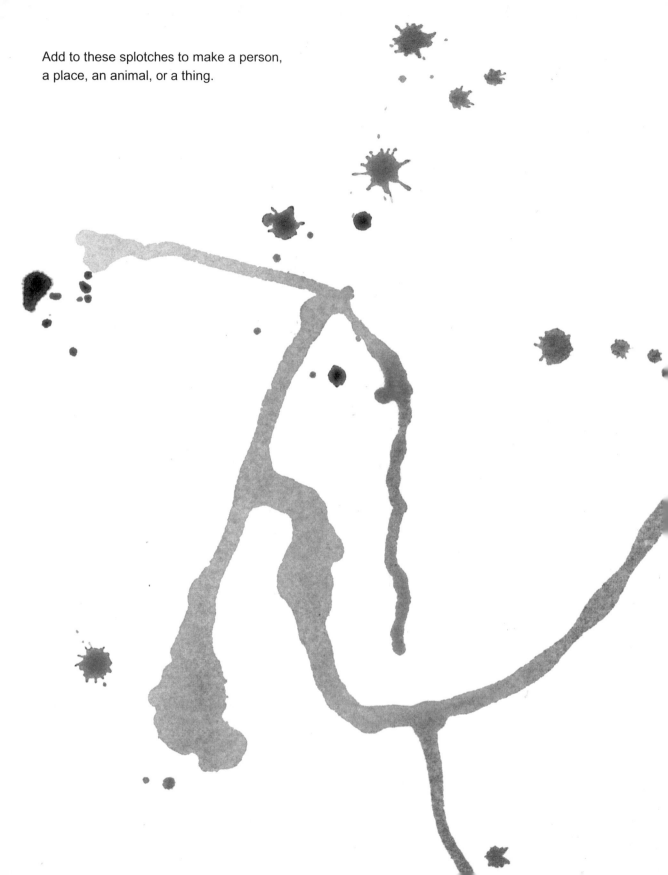

White Space

There are 32 spaces or shapes below. Your assignment is to color them in to create any design you wish, but leave at least 16 shapes blank.

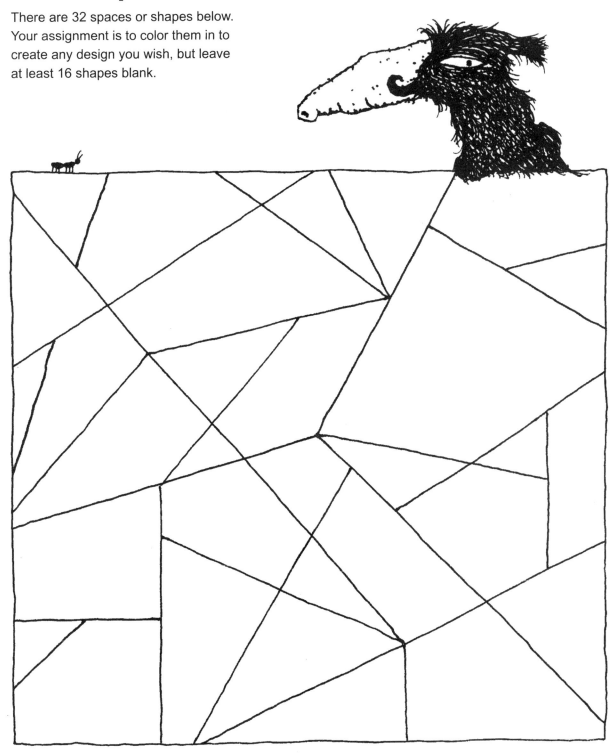

What's going on?
Why are these pages blank?

I think Squeen wanted
"a white space."

Finish the Drawing

Draw at least six elements from the list below
to finish the picture. Color!

COW

HANDS

HAT

TOOTHBRUSH

FORK

KEYS

BEES

SHEEP

MOON

ELEPHANT

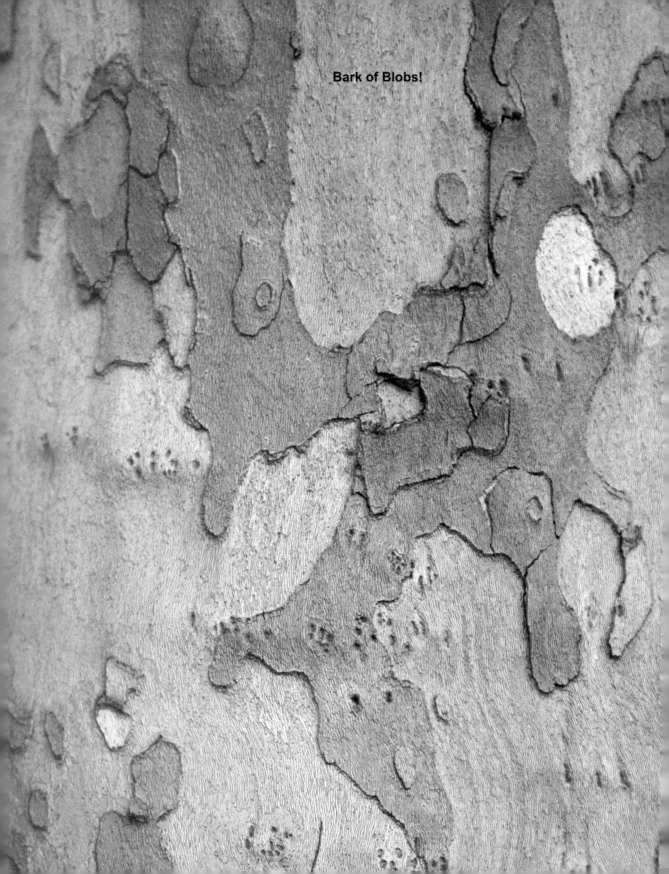

Bark of Blobs!

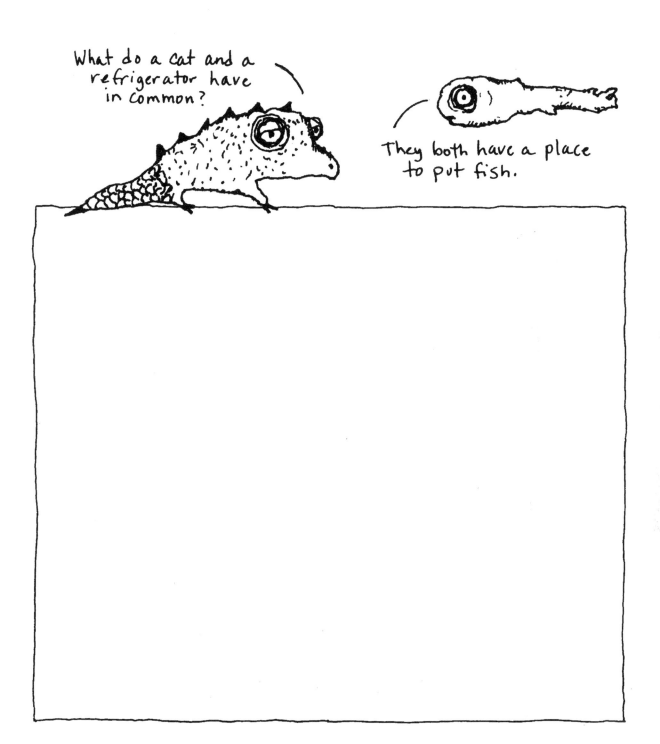

Illustrate the Riddle

Draw from life or photo references, as well as your imagination.

Design Some Silly Glasses

Use the templates below to work out some of your ideas.

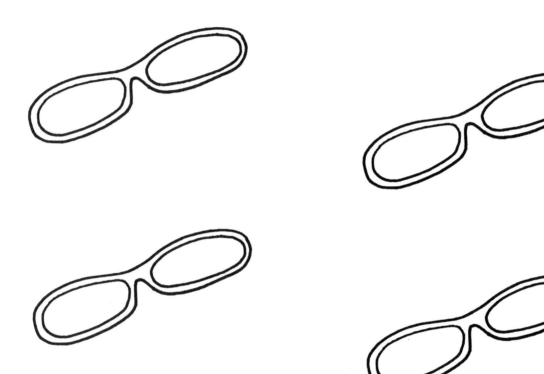

Then draw, paint, or collage your favorite design onto the full-sized template on the next page. Cut out and wear!

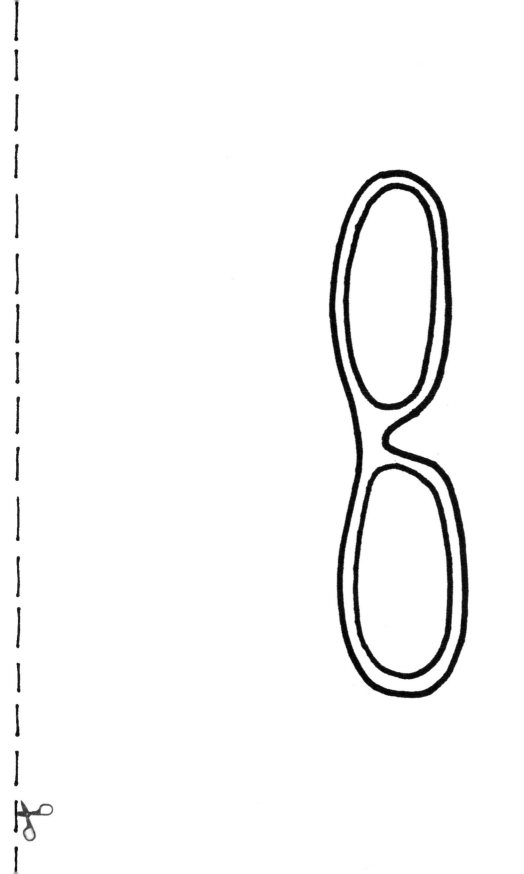

Memorize It

Find an image online of a close-up of a flower, or something similarly detailed. Look at the image for as long as it takes to commit it to memory. Then try to draw it below without looking at your reference. Repeat!

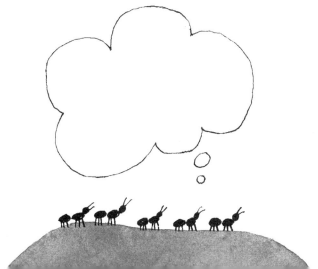

Name It

This creature, part of the Squeen's menagerie, doesn't yet have a name.

Now Flip It

Pretend the _____ is looking in a mirror. Draw its reflection in the space below. Remember to spend more time looking at your reference than your own drawing.

Tip: Try drawing a box around the original animal, and then a box the same size below, so that you have more defined negative spaces to work with.

Note: If your creature looks a bit wonky when finished, pretend it's a fun-house mirror.

Face It

Complete the faces started in the boxes below. Use any media you wish, and rely on your imagination.

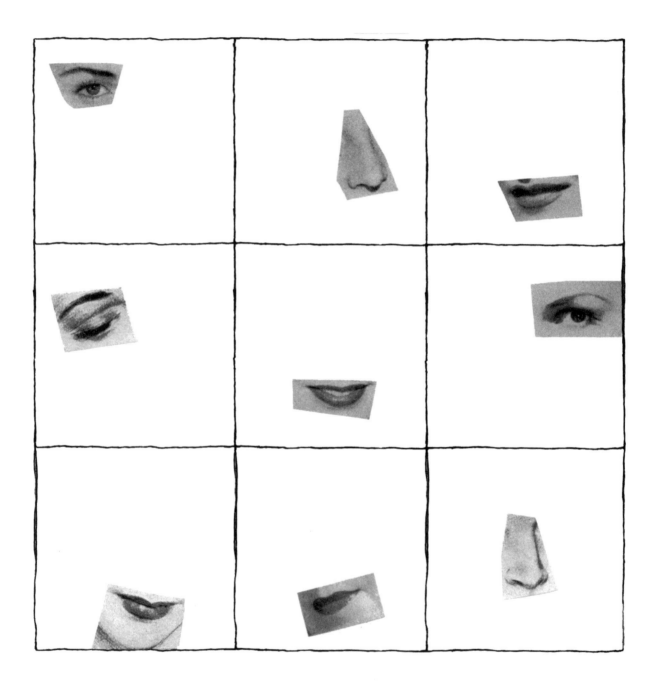

Extra Credit: Complete three while looking at a live model, three from photo references, and three from your imagination.

Totem the Line

Make your own totem pole. You don't have to draw animals if you don't want to...even people work!

Finish the Neighborhood

Draw details on these houses or buildings, including roofs,
windows, bricks, steps, doors, shingles, etc. You can also
add trees, bushes, animals, bicycles....

Elepha-Liza-Foxes

Create a new animal out of three different animals of your choice. (For example, an elpha-liza-fox has an elephant head, a lizard body, and a foxy tail.) The list to the right will help get you started with the animal ideas. If you don't have a pet hyena, for example, you might need to find some photo references online or at the library.

hyena

dog

horse

giraffe

snake

hampster

chinchilla

pig

cow

chicken

turtle

sloth

fish

lion

spider

buffalo

deer

owl

ferret

Don't forget to name your creatures!

Head in the Clouds

The Squeen and her subjects are often described
as having their "heads in the clouds." Your assignment
is to fill these two pages with CLOUDS while experimenting
with at least three different pens, each with a unique
weight and/or color.

Thick pens, thin pens, brush pens...just play around!

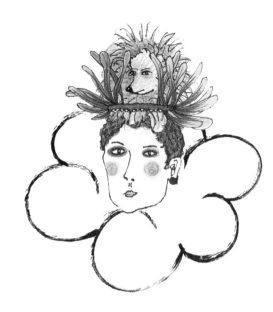

Extra Credit: Put some heads in your clouds!

Blind Contour Feet

Draw your own bare feet three to six times WITHOUT looking at your paper. You will look at your feet 100% of the time. Will the drawings look like feet? Sort of...but it doesn't matter!

~ Really? That's a foot?

Create a Visual Alphabet

Take fifteen minutes to design an alphabet. Fifteen minutes:
too short to fuss, but long enough that you can approach it calmly,
and not frenetically.

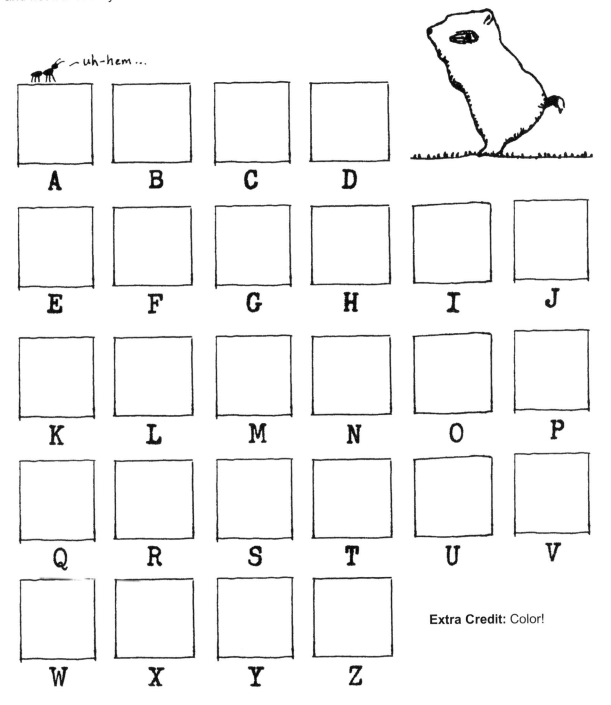

~ uh-hem...

A B C D

E F G H I J

K L M N O P

Q R S T U V

W X Y Z

Extra Credit: Color!

Finish the Drawing

Use the lines below as starting points. Draw creatures, plants, people, or anything else you might see. You can either draw five separate items, or combine the lines into one cohesive drawing.

Newspaper Fun

Find a newspaper and some scissors and glue, and get drawing and writing!

1. Finish the Faces

Draw the other halves of each of these faces.

2. Create an Alien

Find a photograph of a face in the newspaper and chop it in half, as shown. Glue down onto this page. Embellish using a pen. Think "alien guy" or "alien girl."

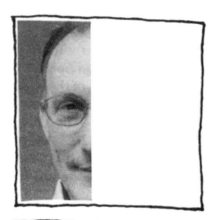

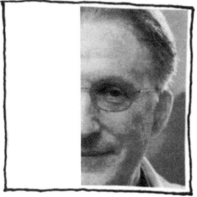

3. Write a Poem

Use only words or phrases cut out from your
newspaper, like this:

bright and sunny

in Pioneer Square

Today,

a reasonable person would

flee,

the second floor

Your poem(s) here:

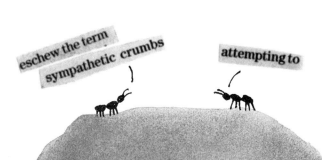

eschew the term

sympathetic crumbs

attempting to

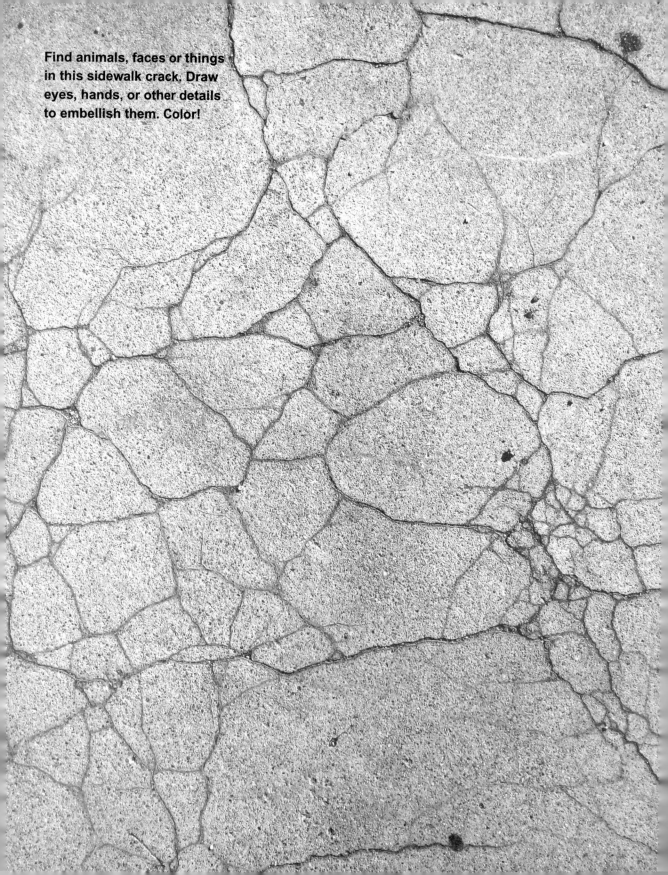

Find animals, faces or things in this sidewalk crack. Draw eyes, hands, or other details to embellish them. Color!

Poodle Power

She is seeing things. And thinking things. But what?

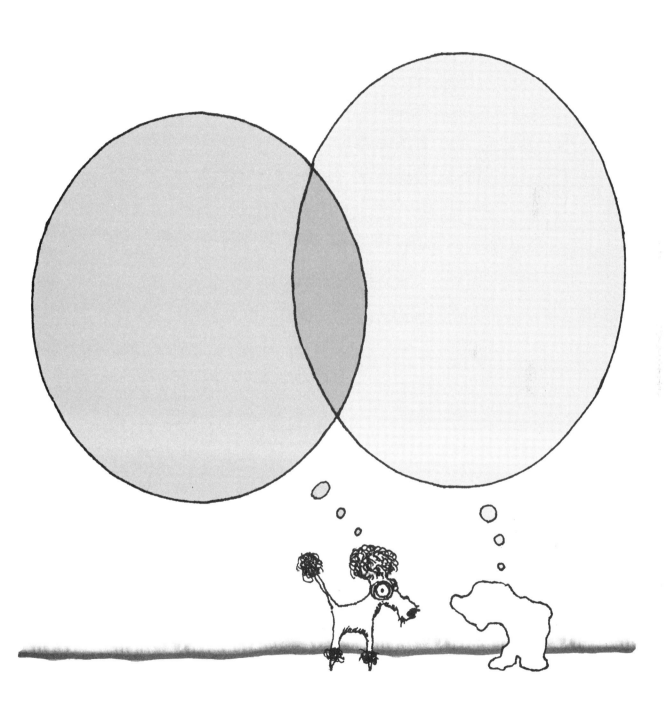

Even More Blob Play

Look at one of these shapes carefully and see if you can turn it into something else, such as a house, a car, whatever. Try to keep them all orientated the same way. Now turn the next blob into something completely different. Repeat three more times.

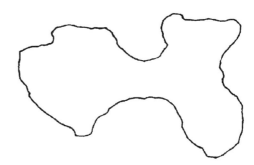

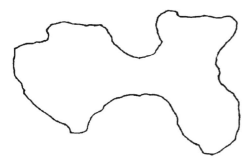

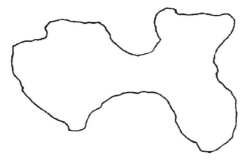

Isn't it interesting how many things you can find in a single shape if you look long enough?

Pick a Noun, Any Noun

First, add words to complete the paragraph below. Then, illustrate your story on the next page using drawings done from both imagination and life. Go with your first impulse; if you want to draw a ball in the middle of the box, for example, do it. Then continue to build your drawing bit by bit, adding elements in response to the ones before it. Try to vary the size and shapes of your elements for balance and variety.

"Okay!" the _____ _____

adjective noun

said to the _____. "Today

noun

I am going to _____ and

verb

_____, and then when I'm

verb

finished I'm going to _____.

verb

Then, tomorrow, I can _____

verb

with my _____ and _____

adjective adjective
"
_____.

noun

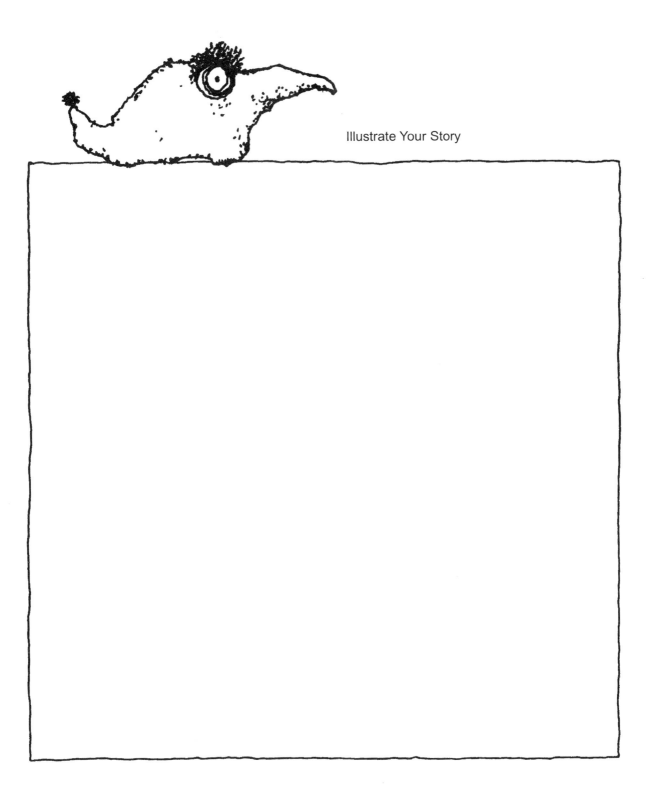

Illustrate Your Story

Draw a family portrait.

Funny Face

Follow the directions in each section, drawing from life or photo references at least half the time.

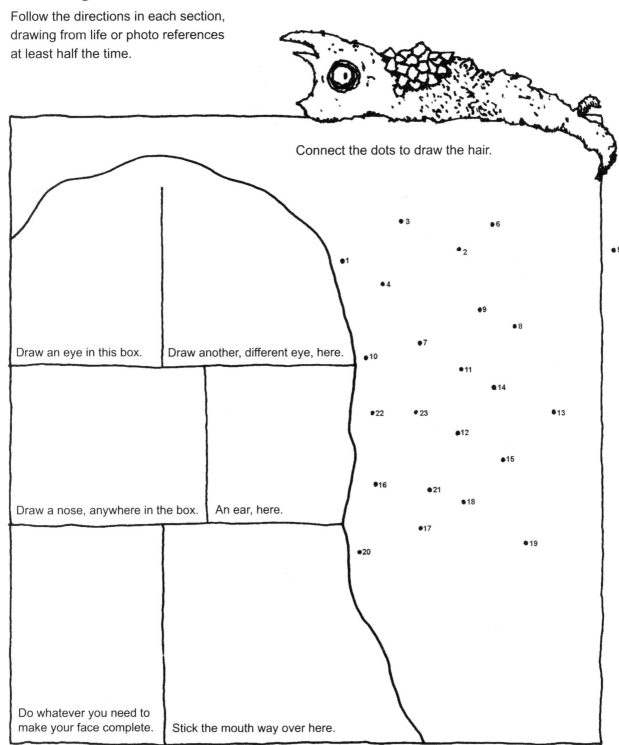

Connect the dots to draw the hair.

• 3 • 6
• 1 • 2 • 5
• 4
• 9
• 8
• 7
• 10 • 11
• 14
• 22 • 23 • 13
• 12
• 15
• 16 • 21
• 18
• 17 • 19
• 20

Draw an eye in this box. | Draw another, different eye, here.

Draw a nose, anywhere in the box. | An ear, here.

Do whatever you need to make your face complete. | Stick the mouth way over here.

Stacked

Draw four more animals from imagination. Stack them on top of each other.

Four Squared

Find an object or scene around you that you like. Draw it four ways, below.

1. Draw it with your non-dominant hand.

2. Draw it as a S-L-O-W blind contour.

3. Draw it using one line only. (Quick, loopy.)

4. Draw it as a "cheater" blind contour.

Four Squared2

Find an object or scene that you DON'T like. (It's important that you push yourself out of your comfort zone sometimes!) Draw it four ways, below.

1. Draw it as a "cheater" blind contour.

2. Draw it using one line only. (Quick, loopy.)

3. Draw it as a S-L-O-W blind contour.

4. Draw it with your non-dominant hand.

Face the Blank Page

(Scary? Always!)

But you
can do it!

A Final Note

You made it to the end...congratulations!

You've drawn fast and scribbly, slowly and methodically, upside-down and all around. You've drawn from life, from references, and from your imagination — and ALL are valid ways to approach drawing.

Did you enjoy each and every thing you did? I suspect not. Rarely will someone respond positively to every drawing exercise.

That's okay! Moving forward, take note of the exercises you enjoyed, and do those most often so that drawing remains fun for you.

Why insist on this? Because whatever your drawing goals — whether you want to draw silly greeting cards or do realistic and detailed pencil portraits of your family — you have the most chance of success if you are enjoying the process.

Not long ago my husband bought me a new bicycle. Steve, a racer, took me around the neighborhood. I felt embarrassed and clumsy riding with him, as I hadn't been on a bike for almost ten years. When he took me up a little hill, I had to get off and walk...ugh!

I spent the next month riding alone around a nearby lake, staying away from any hills and just trying to get back to the bike on my own terms. On one particularly beautiful day I was enjoying the water, the sunshine, and the people with their dogs and thought, "I don't have to be good at bike-riding. I can just stay on the flat parts."

This simple realization was such a relief! And the same applies to learning to draw (or anything you else you might like to learn): Whatever your level, you can enjoy the process — the "doing" can be enough — you don't have to be "good" at it.

But what if you want to improve and get better? Well, there's more to my story:

On the way home that day, I noticed that my legs felt a little stronger. Since I was feeling relaxed and happy, I decided to see how far I could get up the hill Steve had taken me up that first day out.

And you know what? I RODE RIGHT UP THE HILL. The fact that I was simply *riding the bike* helped me improve, even though I hadn't gone up a single hill the whole month.

So I encourage you to try approaching your drawing practice like you might approach riding a bicycle after a ten-year break; even though you can always get into "better shape," that doesn't mean you can't enjoy an easy ride around the lake (and in the process, get in better shape)!

Because no matter what or how you draw — even if you stick to the easy stuff for a while — you are exercising your "seeing" muscles, your hand-eye coordination, and your ability to translate ideas onto paper. And these are the basic skills you want to develop no matter what type of drawing you hope to do.

And if you truly desire to improve in a certain area, you will choose to go up those more challenging "hills" because you are generally enjoying yourself. (Silly, but I think it's a human nature kind of thing.)

Keep it fun!

Carla

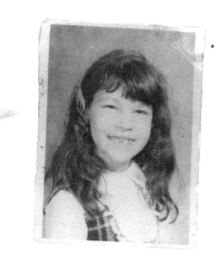

*

Carla Sonheim is a painter, illustrator, and workshop instructor known for her fun and innovative projects and techniques designed to help adult students recover a more spontaneous, playful approach to creating. She is the author of *Drawing Lab for Mixed Media Artists: 52 Creative Exercises to Make Drawing Fun* and *Drawing and Painting Imaginary Animals* (Quarry Books).

The Art of Silliness is based on a popular online class of the same name. Carla makes her home in Seattle and shares space with her photographer husband, a game-playing teenager, and her laptop.

www.carlasonheim.com
www.carlasonheim.wordpress.com
www.theartofsilliness.com

* 2nd grade photo (1970).